How to
USE LIGHT
CREATIVELY

HPBooks®

Publisher: Rick Bailey
Editorial Director: Theodore DiSante
Art Director: Don Burton
Book Assembly: George Haigh
Book Manufacture: Anthony B. Narducci
Typography: Cindy Coatsworth, Joanne Nociti, Michelle Claridge

Notice: This material was first published in England in the magazine You and Your Camera, produced by Eaglemoss Publications Limited. It has been adapted and re-edited for North America by HPBooks. The information contained in this book is true and complete to the best of our knowledge. All recommendations are made without any guarantees on the part of Eaglemoss Publications Limited or HPBooks. The publishers disclaim all liability incurred in connection with the use of this information.

Published by HPBooks, Inc., P.O. Box 5367, Tucson, AZ 85703 602/888-2150
ISBN: O-89586-113-5 Library of Congress Catalog No. 81-82137
©1981 HPBooks, Inc.
3rd Printing

How to
USE LIGHT
CREATIVELY

Contents

The Light Source

Lighting is one of the main ingredients of a successful photograph. By controlling the light source, you can make a subject look attractive or unattractive. Objects can be made to look either familiar or unrecognizable.

When away from controlled lighting in a studio, many photographers accept whatever lighting happens to exist. They think there is no alternative. How can you move the sun or roll back the clouds?

In fact, there is a lot you can do to gain control of existing light. This book will help you understand some basic principles of lighting so you can improve your photography.

Consider a family on a beach, where the sun is out. The sun is the *primary light source*. Every three-dimensional element in the scene, including eyebrows and noses, casts dark hard-edged shadows. On faces, these are unflattering. You can do

several things to solve the problem. Use a large beach umbrella or any other large object to cast a shadow over the group. Or, move the group into the shade of a building. This softens the hard-edged shadows. Base exposure on the subjects in shadow.

▼ You can use direct sunlight and dark shadows for dramatic effect. Clive Sawyer used it successfully here by composing the scene so the main subject seems spotlit against the dark background.

This is only one solution. The photographer who understands some of the basic ideas of photographic lighting can quickly improvise others, depending on the particular situation and the purpose of the picture.

WHAT IS GOOD LIGHTING?

Good lighting for a passport photograph, a "wanted" poster, or an actor's publicity shot is different in each case. What makes good lighting usually depends on the photo's particular purpose. When you think about good lighting, consider the following three functions.

The first function of lighting is to illuminate the subject so you can focus, meter, and expose film. Usually, but not always, the more light the better. Focusing is easier because the viewfinder image is bright. There will be enough light so you can use slow film for good image sharpness, small apertures for greater depth of field, or fast shutter speeds to freeze action.

The second function is to convey information about the subject's shape, size, color, and texture. A two-dimensional photograph must convey the impression of three dimensions.

We can move our heads from side to side to see the position of elements within the scene, enhancing the three-dimensional view of a subject. We can also concentrate on a small part of a scene and focus on it. Because a camera does not operate in the same way as our vision, controlling the light is important to communicate these elements to the picture's viewer.

The third function is to create a mood for the image. The lighting can imply the value of an object or suggest more indefinable qualities, such as honesty or purity, happiness or misery. It can also subdue some aspects and emphasize others. Look at advertising photographs to see how lighting causes you to attribute certain qualities to a subject or situation.

Any lighting that accomplishes the intended photographic purpose is good lighting.

TYPES OF LIGHT SOURCES

Many different words are used to describe lighting: *hard, harsh, soft, diffuse, flat*. These words are often used carelessly, which leads to confusion. For example, the term *flat lighting* is commonly used to describe three different forms of lighting—light from an overcast sky, light from a flash unit mounted on the camera, and light reflected into the shadows by white

A problem with a *small-source light,* such as direct sun (right), is that the subject casts dark, hard-edged shadows. These can complicate the composition and be unflattering to the subject.

When direct sunlight is blocked or diffused, shadows become lighter and edges softer (above). This lighting is more suited to this subject.

walls or other reflectors. None of the terms is very accurate.

A better way to talk about lighting is to refer to the nature of the *effective light source.* This is whatever lights the subject directly, with nothing between the effective source and subject except air. In the case of people on the beach on a clear day, the sun is both the primary and the effective light source. When the group is put in

shadow, direct sunlight no longer illuminates the scene. The *effective* light source becomes the sky, beach, and whatever reflective surfaces illuminate it. The sun is still the *primary* light source.

Knowing about the effective light source is important because *the nature of the effective light source determines qualities of the lighting.* The size of the effective light source is the most important factor.

Large Light Source—This is a source that is large compared to its distance from the subject. In this case, light strikes the subject from many directions, making it *nondirectional.* The subject casts weak shadows because light comes from all around. Examples are people under a beach umbrella, under an overcast sky, or beneath a series of fluorescent lights on a white ceiling. This kind of light is also called *soft light.*

EFFECT OF LARGE LIGHT SOURCE

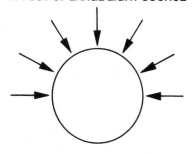

Small Light Source—This is a source that is small compared to its distance from the subject. It is *directional*—you can tell what direction light comes from by observing the hard-edged shadows cast by the subject. Examples of small sources are bright sun in a clear sky, a flash mounted on camera, or a bare light bulb illuminating the subject.

A small source can be physically large but is so far away it appears small. This is why the sun on a clear day acts like a small

EFFECT OF SMALL LIGHT SOURCE

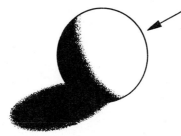

source. Light from a small source is also called *hard light.*

Medium Light Source—Between large and small is an infinite range of light sources. For simplicity, just one intermediate size is defined here. A medium source is defined as being about as large as its distance from the subject. For example, a window acts as a medium source if it is three feet square and the subject is within

three or four feet of the window. A medium light source gives directional light and causes shadows that are softer than those due to a small source.

Medium-source lighting occurs indoors and outdoors. When sunlight strikes any light-colored surface, such as a wall, the surface may be a medium light source. Sometimes, during heavily overcast weather, clouds part to reveal a brilliantly lit cloud. This is an unusual and dramatic example of medium-source lighting. You can produce a similar effect by reflecting or diffusing a small light source with material that is approximately as big as it is far away from the subject.

EFFECT OF MEDIUM LIGHT SOURCE

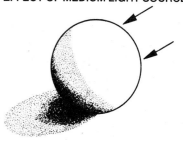

▼ An overcast sky is large-source lighting. Shadows are faint and colors stand out well. A complex composition is kept as simple as possible with this kind of light.

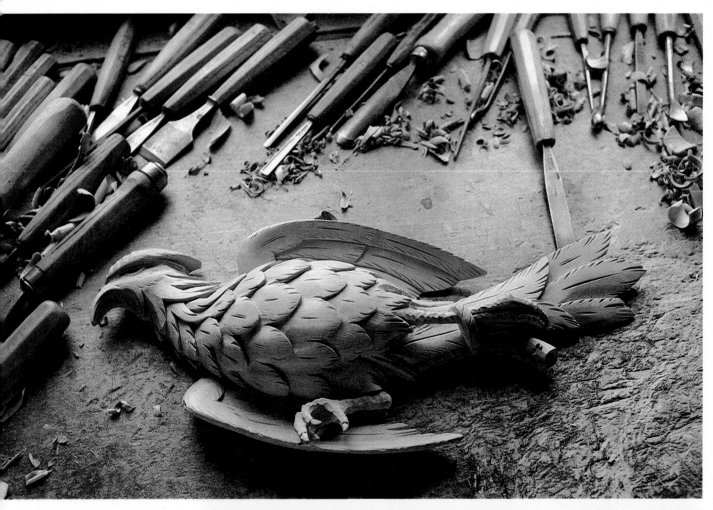

▲ A medium-source light illuminated the carving from behind. This results in better modeling and softer shadows than with a small-source light.

▶ This is another example of lighting from a medium source. For this photo, a sheet of white paper reflected light from a window onto the subject.

Lighting Different Surfaces

When directional light strikes an object, three areas are created on the object—the *highlight*, *lit* and *shadow* areas. A highlight is caused by a small area on the subject that appears very bright because it reflects light directly to your eye. Usually the reflected light is so bright that you cannot see surface details in that area. The lit area is bright and illuminated directly by the source, but you can see surface details. The shadow areas are shaded from the light source by another part of the subject or some nearby object.

▲ Sand is a typical matte surface. A minute highlight appears on each grain. Color is strongest in the lit area. The edge of the shadow shows texture and form.

The combination of these three areas tells the viewer about the dimensions, texture and color of the subject. There may also be a cast shadow.

To understand each area, place an orange or similar small object on a dark surface. Light it from one side with a single, small light source, such as a desk lamp.

Notice how the shadow and lit areas and the boundary between them show the object's shape. Color comes from the lit area. Texture appears at the edges of the lit

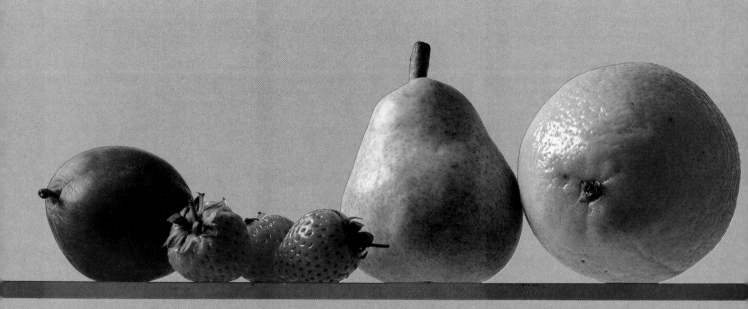

area. Texture is often most apparent at this area because the light strikes the surface irregularities from the side. The lit area may include a highlight.

TYPES OF SURFACES

If you replace the orange with a matte object, such as a peach or a tennis ball, you see that the highlight is practically invisible. Form and texture are now visible on the border of the shadow and lit areas.

If you substitute a shiny object made from glass or metal, you will notice the predominance of the highlight area and how sharply the lit area merges into the shadow.

The relative sizes of the three areas are determined by the nature of the surface. Depending on which subject area you want to emphasize, the type of surface you photograph influences how you should control the lighting.

For simplicity, surfaces are divided into three categories—*shiny*, *matte* and *semi-matte*. In reality, there are very few totally matte or shiny objects. These categories

▲ Lighting shows shape, color, and texture.

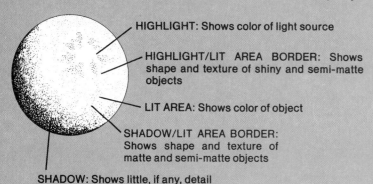

HIGHLIGHT: Shows color of light source

HIGHLIGHT/LIT AREA BORDER: Shows shape and texture of shiny and semi-matte objects

LIT AREA: Shows color of object

SHADOW/LIT AREA BORDER: Shows shape and texture of matte and semi-matte objects

SHADOW: Shows little, if any, detail

▼ A medium-source studio light was used for the photo of fruit at the bottom of these two pages. The fruit surfaces range from the matte skin of a plum to a shiny, polished apple.

Now look at the fruit in terms of the diagram at left. Observe the differences between highlight, lit area and shadow on various surfaces. Notice which areas show texture and form, and which show color.

On the semi-matte orange, form and texture show best on the borders of the highlight/lit area and shadow/lit area. On the apple, only the edge of the highlight shows this kind of detail.

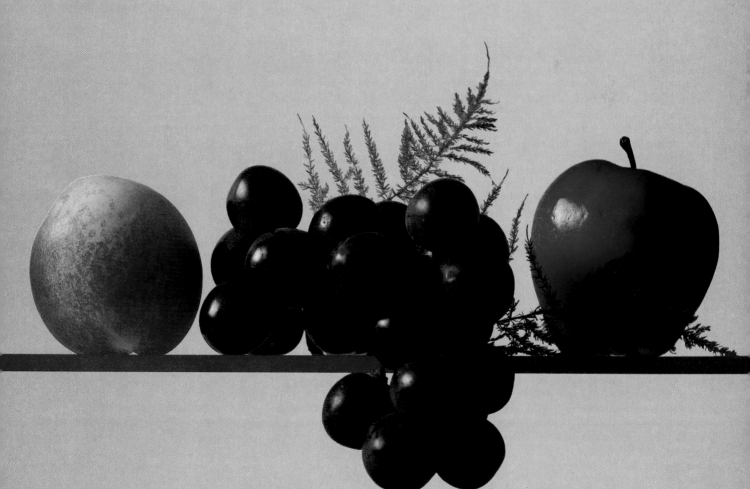

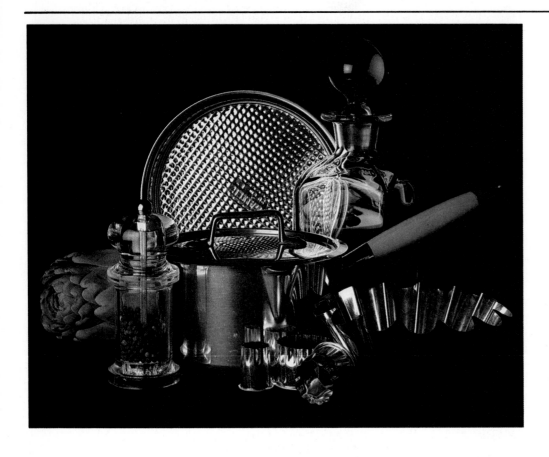

◀ Except for the artichoke and brushed aluminum pan, the objects in this photograph are shiny. Highlights indicate the shape and texture of shiny objects. The light used for this scene was a studio flash inside a rectangular reflector. You can see it reflected in the top of the glass decanter.

▶ The body of the dull clay crock is a good example of a matte object without an obvious highlight. Texture is clearest on the shadow/lit area border. Compare this with the semi-matte onion, which has a distinct highlight and visible texture in both borders.

represent objects that are *predominantly* shiny, matte, or semi-matte.

SHINY OBJECTS

In the case of shiny surfaces, such as aluminum foil, polished steel or glass, highlights are very obvious. Lit and shadow areas tend to merge. For this reason, when lighting shiny objects, you should mostly consider the shape, size and position of the highlights.

These highlights are reflections of the light source and do not always show the color or texture of the object. Any texture of a shiny object appears in the lit area or its edges.

Lighting Suggestions—When you use small-source lighting, a small highlight is produced. This does little to show the shape of the object, so small light sources are not often used with shiny objects. In fact, for many years photographers have constructed the largest possible effective light source when photographing shiny objects. Recently there has been increasing use of medium-source lights, particularly a source with a rectangular shape.

MATTE OBJECTS

An object, such as a brick or tennis ball, appears matte because its surface is irregular and has many fine indentations. Therefore, when it is lit, there is not just one highlight but thousands or millions of minute ones reflected in all directions. In this case, the total effect of the highlights is not very strong. A comparison between the two still-lifes on this and the facing page clearly shows the difference between the highlights of shiny and matte objects.

On a matte object, the lit area shows the color of the object. The shadow does not have any modeling or texture. If there seems to be some, it is usually due to a second light source, such as a nearby reflecting surface, illuminating the shadow area. The edge of the shadow, where the lit area and shadow merge, shows most detail.

Lighting Suggestions—To emphasize texture, create a border between the lit and shadow areas. This means choosing a small or medium light source and positioning it so the border falls on a prominent part of the subject.

Top, bottom or side lighting puts this border between shadow and lit areas approximately in the center of the object. The next section discusses these positions.

SEMI-MATTE OBJECTS

Dulled copper and brass, semi-gloss or flat paint, most plastics, human skin, and oranges are examples of semi-matte surfaces.

With these, both the highlight and shadow areas are clearly distinguishable from the lit area. The highlight may show the color of the object in a lighter shade. The shadow is dark unless light from another direction reaches the shadow areas. The lit area shows the subject color strongest. Texture appears in both the highlight and the lit areas.

Lighting Suggestions—To emphasize subject color, arrange the lighting so the maximum amount of lit area is visible. Minimize the shadow area by using front or quarter lighting. The next section describes these positions in more detail. Minimize the size of the highlight by using a small light source.

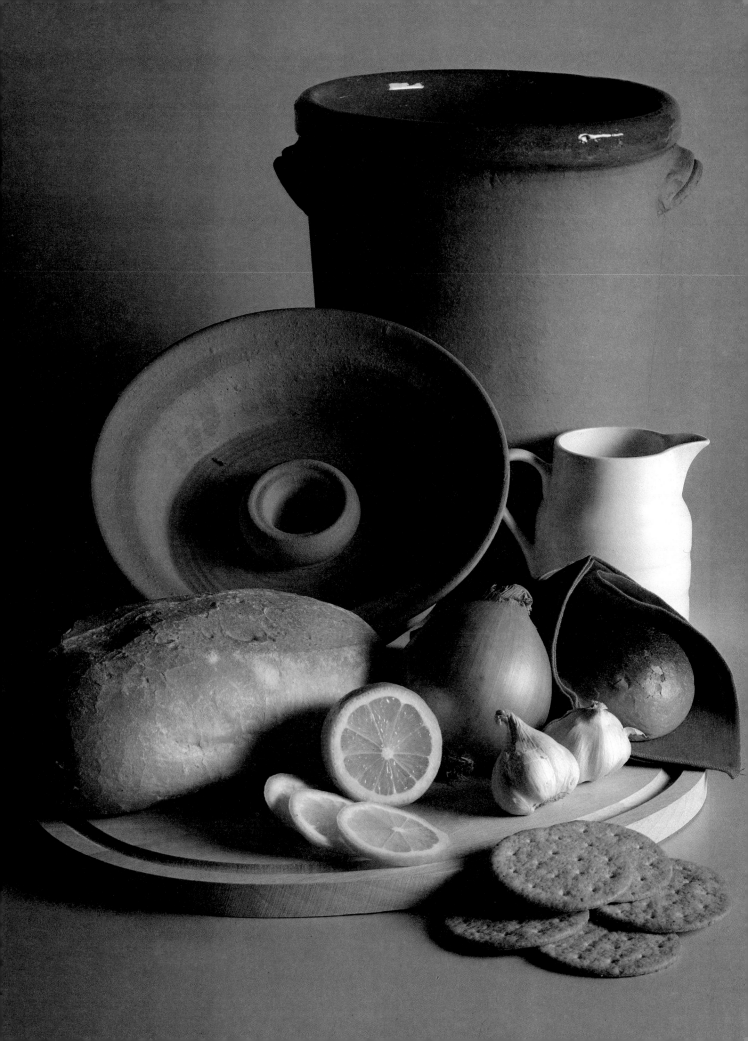

Positioning the Light Source

The size of the light source is the main factor affecting lighting qualities. Next is the position or angle of the light source. The three seascapes here, illustrating a scene at three different times of day, show the vast difference the angle of light can make. Notice how the mood and subject details vary with the changing light direction.

With small light sources, or with shiny objects, small changes in light position can alter lighting significantly. But in most cases, moving the light up or down slightly does not have a great effect. So it is usually more helpful to think in terms of five basic lighting positions. These are *front*, *top*, *side*, *quarter*, and *back lighting*.

CHOOSING THE ANGLE

The position of the light has two effects. One is *subjective*. Lighting from different angles can be associated with different emotional situations. For example, light on a face from below can look very sinister. Top lighting can create a holy mood.

The other effect of the light position is *objective*. It is the amount and quality of detail the lighting conveys. More simply, as the light moves around an object, you see more or less shadow, more or less illuminated area, and more or less highlight.

Choice of angle should be determined by where you want the highlight, shadow or lit area to be, and what type of information you want to convey about the subject.

With all shiny objects, for example, it is the shape and break-up of the edge of the highlight that reveals the shape and texture of the subject. Therefore, a flat shiny surface, such as wet pavement or wet sand, will usually not show much surface detail unless you intentionally try to highlight it. Look again at the examples of the seascape photographed at different times of the day.

POSITIONING THE LIT AREA

As described earlier, the lit area shows subject color. Therefore, front and quarter lighting, which create large amounts of lit area, help show a lot of color.

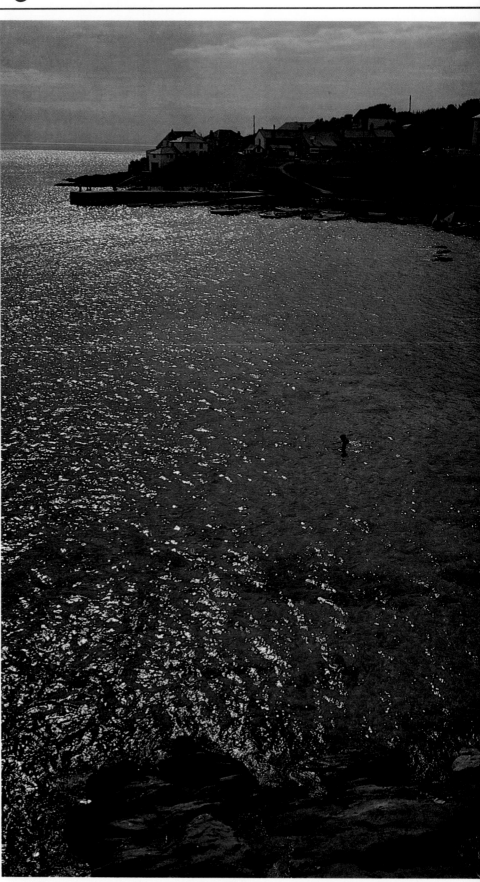

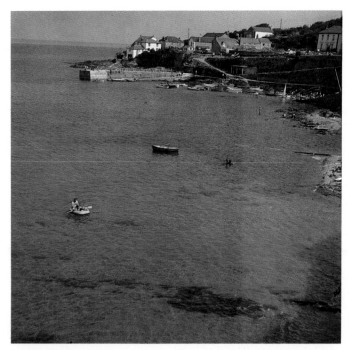
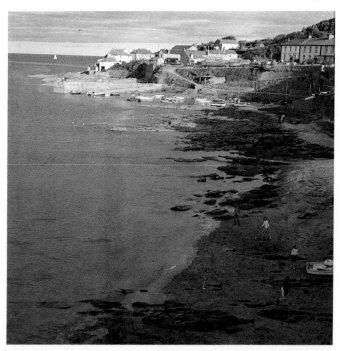

The seascapes at left and above show how color, texture, modeling, and tonal relationships change with the angle of the light. The photograph at left, made with small-source back lighting, has the least overall detail. Light reflects from the water to emphasize rip-ples. The center photo was made with large-source front lighting from a cloudy sky. Shadow details are visible and there is good color saturation. The sunlit view at right is lit from the side. It shows good detail in lit areas, but the shadows lack detail.

▶ This orange shows what happens when a semi-matte object is lit by small-source lighting from five different angles.

TOP AND SIDE LIGHTING: Half the object is in shadow. Good for texture and modeling.
BACK LIGHTING: Large shadow area and small, strong highlight. Lit area/shadow border indicates shape and texture.
FRONT LIGHTING: Good color, but little modeling or texture.
QUARTER LIGHTING: Gives effect of both side and front lighting.

TOP LIGHTING

SIDE LIGHTING

BACK LIGHTING

FRONT LIGHTING

QUARTER LIGHTING

POSITIONING THE HIGHLIGHT

The position of the highlight depends on the position of the light source. A rounded object will always show a highlight somewhere. A flat object may lose the highlight on an edge. Because most objects are a combination of flat and rounded surfaces, you can usually place the highlight on an area where it is most useful for the effect you want. For example, in portraiture you may want to emphasize furrows on the brow or wrinkles at the corners of the eyes with highlights.

You can emphasize the edges of dark objects photographed against dark backgrounds by placing the source so the highlight is at the edges. Of course, this technique can only work when the highlight is strong enough to stand out clearly, such as with a shiny object.

POSITIONING THE SHADOW

With matte objects, and to some extent with semi-matte objects, the merging of shadow and lit areas produces modeling of shape and texture. Just as you can position the edge of a highlight on a flat, shiny surface, you can also position the edge of the shadow.

For example, when photographing the front of a building, an architectural photographer will usually wait for the sun to cast light that cuts across the front of the building, accentuating fine details. A few minutes earlier, the front may have been in total shadow.

A few minutes later the front may be completely lit. This is good for color but unlikely to show fine detail in shape and texture. Between these times, *both* light and shadow exist on the building.

The portrait photographer may place the edge of the shadow down the wrinkles of the subject's face, as shown opposite.

FRONT LIGHTING

With front lighting there is virtually no shadow area as seen by the lens. The edge

▶ Here, side lighting emphasizes the man's wrinkles.

▼ Below right: This photo shows street lighting reflected by a car. You could change the position of the highlights by moving camera position.

▼ Below left: Side lighting accentuates surface details.

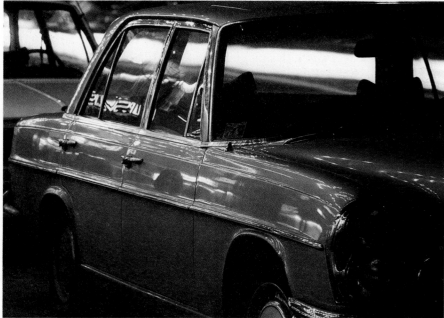

of the shadow is almost out of sight. Therefore, it creates very little texture or subject modeling. However, it does give good color rendition because the lit area is relatively large.

The highlight is practically in the center of each object. The resulting effect can be poor, especially with portraits. For example, a highlight in the center of the eyes is not very flattering. Usually, this is the lighting given by on-camera flash pointed straight at the subject.

Medical photographers use front lighting because the good color and absence of shadow on the subject ensure that skin color shows well and no detail is lost. Because of the way they use photos, they don't need to emphasize texture and shape. Press photographers often use front flash lighting because it is simple and quick.

SIDE LIGHTING

With side lighting, the edge of the shadow generally runs down the center of each object in full view. This is the most commonly used angle when texture must be emphasized. See pages 42 and 43.

QUARTER LIGHTING

Quarter lighting is halfway between front and side lighting. It keeps the edge of the shadow in view, while showing a little more of the lit area but less shadow than side lighting. Probably more pictures are taken with quarter lighting than any other directional lighting. It is also called *half-side lighting*.

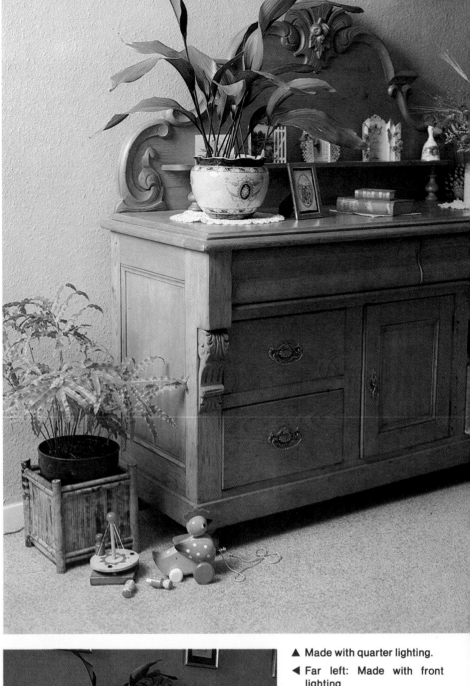

▲ Made with quarter lighting.

◀ Far left: Made with front lighting.

◀ Left: Made with side lighting.

These three lighting angles are common. The front lit picture has best color, but looks two-dimensional. The picture lit from the side has less color but more shadow for a good three-dimensional effect. The photo above made with quarter lighting is good for both color and depth.

TOP LIGHTING

Top lighting is from above. The edge of the shadow usually runs horizontally across the center of each object in full view of the camera, leaving the lower half of the object in shadow.

Even though there is no objective difference between top and side lighting, there is a difference in the subjective effects. Top lighting does not flatter the human face. Eyes and jowls darken; the nose and forehead lighten. Most people find this unpleasant in a photo.

The best solution is to add or subtract light so the light is no longer exclusively from the top. For example, you can use a large white reflector or shiny object to bounce some light for a front-lit effect. Or, try something dark such as an umbrella above the subject's head to reduce the light from above.

BACK LIGHTING

With back lighting, most of the subject as seen by the lens is in shadow or silhouetted. Highlights surrounding the subject become dominant. This is because the subject becomes darker and less interesting than the light skimming around it. The effect is so powerful that this lighting angle is often used to make a subject look mysterious.

When a series of shapes recedes into the distance, one behind the other, such as a range of hills, back lighting is sometimes used to separate elements. A highlight rims each dark or silhouetted object. This creates a tonal gradation from lit area to highlight. The double effect of obscuring much unwanted detail while creating a large highlight has made back lighting a favorite among many photographers.

◀ Top lighting is not very flattering to a person's face. You can avoid it by reclining the subject so the top light becomes front light.

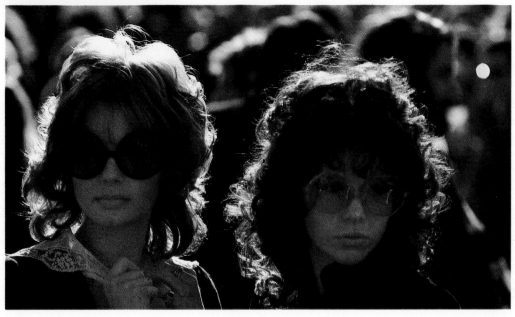

▶ Back lighting outlines heads with highlights, which separate the subjects from the background. The front of the subjects is illuminated by reflections from surrounding surfaces.

Small-Source Lighting

You can produce successful pictures if you control the size of the light source. The three basic sizes—small, medium and large—have been defined. This and the following two sections describe their advantages and disadvantages, and how to overcome problems that may occur.

WHAT IT IS

Small-source lighting, also called *hard lighting*, is directional and makes the subject cast dark hard-edged shadows. It is common because the sun in a bright, clear sky is a small source. In spite of its enormous size, it is so far away that it is small relative to subject distance.

Other small light sources are direct flash, household lamps, and studio lamps used in small reflector housings. The tests for a small source are: Can you see the direction of the light? Does the subject cast a hard-edged shadow? If the answer to both questions is *yes*, the source is small.

WHAT IT DOES

Because of the well-defined shadows this type of lighting creates, small light sources make a picture seem more complicated.

Highlights are small and bright. The dividing line between lit area and shadow is distinct, with little space for the subtle tones that show the subject's shape.

ADVANTAGES

Though small-source lighting may present some problems, it is ideal for certain subjects. It works well with small simple objects when you want to complicate the way the subject looks. Hard-edged shadows and small highlights may add some compositional interest to a simple subject that might otherwise make a boring photo.

You can emphasize fine texture by placing the lit area/shadow border for best effect.

Small-source lighting can be projected considerable distances, and its distribution is easy to control. A spotlight is always a small source.

Water-spray or rain produces a rainbow when back lit by a small source—the sun. Ghost images in a lens are made by shooting into a small source.

DISADVANTAGES

Because subjects lit by a small source cast hard-edged shadows and show textural detail, small-source lighting is not always the most flattering for photographing people.

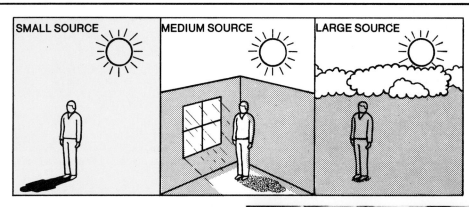

| SMALL SOURCE | MEDIUM SOURCE | LARGE SOURCE |

▲ You can usually determine the effective size of a light source by observing the shadows cast by a subject. A subject lit by a small-source light casts a hard-edged shadow. Medium-source light leads to a distinct but softer-edged shadow. A subject in large-source light produces faint and indistinct shadows.

▼ The jug was lit by a small-source light in the quarter position. Notice the small but distinct highlight, the hard shadow edge and good texture. Photo by Malcolm Warrington.

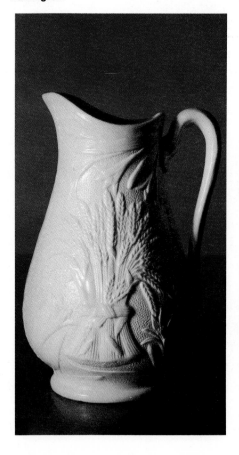

◀ Direct sunlight from the side makes the glossy green paint shine and emphasizes texture on all surfaces. Photo by Suzanne Hill.

▼ Direct sunlight results in many small highlights when reflected from choppy water. This makes the water look textured. Photo by Suzanne Hill.

If the scene is composed so the source gives side lighting, a dark shadow edge cuts across the subjects' faces. Facial lines are made obvious. If it is hot, any perspiration on faces becomes many tiny highlights.

Because of the excellent color in the lit area provided by a small source, a red nose appears even redder. There is a lack of modeling throughout the whole scene.

CHANGING THE LIGHTING

You can overcome this problem by changing a small source to a medium or large source. One way to do this is to find something to block direct sunlight. The best solution depends on the actual situation. Outdoors, you can use a beach umbrella or the shadow of an awning.

Or, you can wait until the sun is diffused by a cloud or haze. In each case, the principle is the same—use a large or medium source instead of a small one.

Back Lighting—Another way to change the lighting is to move around until the subject is backlit. Because the camera now faces the sun, you should use a lens hood to prevent stray light from striking the front lens element. This assumes that the sun is not so low as to actually be in the picture. If it is, it may cause severe flare, which lowers image quality. If necessary, move the subject in front of the sun to block it.

With direct sunlight lighting only the edges of the subject from behind, faces and bodies are lit by reflected light from the surrounding sand and sky. This front light is large-source lighting. It is certainly not as bright as sunlight. For best exposure, meter the area lit by reflected light. Exclude the back light from the metered area.

▶ Strong shadows intensify the feeling of depth in this photo by Adam Woolfit.

▼ Placing the subject in shade on a bright sunny day is a good way to eliminate harsh, unflattering shadows. Photo by Tim Megarry.

▶ The subject has her back to direct sunlight. Her face is lit by softer light reflected from surrounding surfaces. Photo by John Garrett.

This combination of small-source back lighting and large-source front lighting is extremely flattering. It makes almost any subject look better. The highlight glow around the subject attracts the viewer's attention to the handsome effect of even, large-source lighting.

You can lighten the harsh shadows of side lighting by filling them with more light. This is called *lowering lighting contrast.* In this book *lighting contrast* is defined as the difference between the light in the brightest area and the light in the shadow area.

Use any white, silver, or pale-colored material to reflect some light back into the shadow areas. This will result in shadows with more detail. You can make or buy reflectors. For example, use a white card, metal panel, or anything at hand to reflect light into a face.

▶ Strong directional light from the side creates unflattering shadows under chin, eyes and nose. It accentuates every detail—even single strands of hair. Photo by Richard Greenhill.

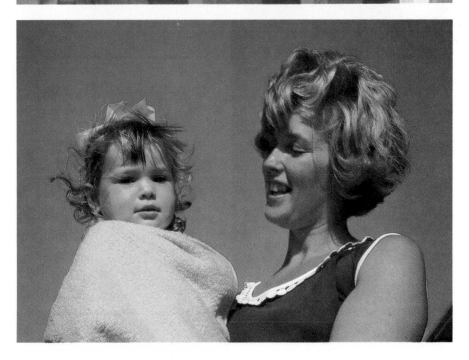

CHANGING THE COMPOSITION

Instead of changing a small source to a larger source, you can change the composition to suit the lighting characteristics. For example, move so the sun is behind you. The subjects will then be lit from the front. Dark shadows are reduced. If you do this, be sure *your* shadow doesn't intrude into the picture area.

Faces are now entirely in the lit area and are not as shadowed as they would be with side lighting. Facial lines are less obvious.

Any perspiration or redness of a nose will still show. One solution to these problems is to use a soft-focus lens attachment to smooth out the light on the faces.

Because small-source lighting tends to complicate a subject with shadow and reveals detail, you may wish to simplify the picture. Try a more formal arrangement of the subject. Watch for irritating flaws, such as unruly hair or creases in clothing.

A shadow problem can be solved if you lower the camera angle and shoot up slightly. Shadows on the ground are no longer in the picture. Because the top half of most scenes is usually much simpler that the bottom half, this immediately simplifies the photograph.

▼ Strong side lighting clearly defines the fluting on the columns. Shadows add interest to the right side of the composition.

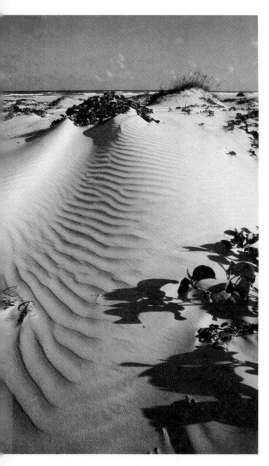

▲ Strong side lighting is good for landscape photography. Notice how it accentuates shallow ripples in the sand. Photo by Jack Taylor.

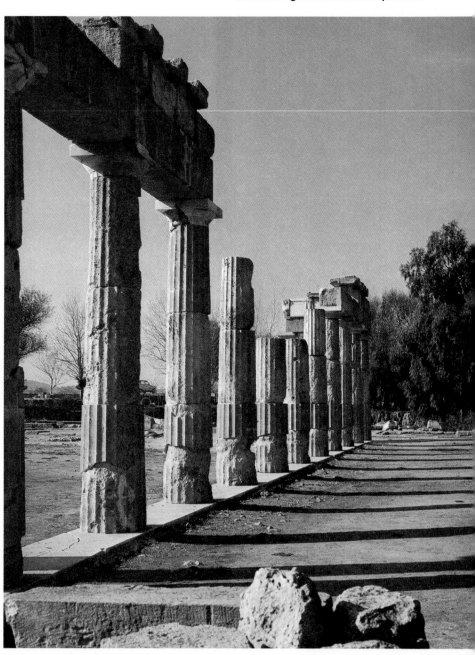

Getting rid of shadows is not easy. You can use a second light to fill the shadows, but this sometimes leads to a second weaker shadow. Solve this problem by moving the second light to camera position so the subject casts the second shadow directly behind. This can produce a second set of highlights.

USING SHADOWS CREATIVELY

Shadows can be very important in composition. Use them to form patterns, or to balance the subject matter.

The hard-edged shadows characteristic of small-source lighting can be used to show the shape of objects. For example, the shadow of a telegraph pole is bent if it is cast on the dips and rises of a ditch. The shadows cast by clouds on a hill often define the shape of the hill.

Shadows can also have symbolic effect and can be used to create images with emotion and mood. For example, they can give a menacing, sinister effect, such as when a long dark shadow follows a lone figure.

SUMMARY

Small-source lighting will produce a:

Small Highlight—This results in good color but gives no modeling to a shiny object.

Hard Shadow Edge—This makes texture visible, but may give little modeling to matte objects.

Dark Shadow—This can be used creatively but can also cause problems by hiding detail.

◄ Without the strong shadow, this picture would be very dull. Try using shadows creatively. Photo by Jack Taylor.

Large-Source Lighting

SMALL SOURCE MEDIUM SOURCE LARGE SOURCE

The opposite of small-source lighting is *large-source lighting*. In this case, the effective light source is so large or close to the subject that it practically surrounds the subject with light. Because light comes from many directions, there are few dark shadows.

The most common large light source is an overcast sky. White ceilings with rows of fluorescent tubes also act as a large light source. When flash is bounced from a

light-colored surface such as a ceiling, the bounce surface becomes a large light source.

A large light source is not necessarily bright. The test of a large source is: Does the subject cast prominent shadows? With large-source lighting, shadows have soft edges.

WHAT IT DOES

Large-source lighting tends to simplify a subject. Highlights spread out—often until they are invisible. This tends to show color well.

◀ Large-source lighting produces a spread-out highlight. Shadows are light and full of detail. Photo by Malkolm Warrington.

▼ A complex composition with many elements is ideal for large-source lighting. Photo by Richard Greenhill.

Another advantage of large-source lighting is its simplicity and unifying effect. It emphasizes subject form and detail. Shadows are open and full of detail.

Shiny Objects—A large source is ideal for a shiny subject. Because the source is large, it reflects in the object as a large highlight that follows the contours of object. This effect tells the viewer that the object is shiny.

This is why photographers who photograph large shiny objects like cars and motorcycles like to photograph outdoors on overcast days. The sky acts as a large source. Its reflection in the object is not distracting. Instead, the contours of the object are emphasized.

Matte Objects—In the case of matte objects, it is the edge of the shadow that gives modeling and texture. With large-source lighting, this edge is soft and gradual; the lit area gradually changes into shadow area, which is open and shows detail.

For this reason, large-source lighting gives extremely subtle modeling—so subtle that it is sometimes ineffective. Texture, too, is reduced.

USING LARGE-SOURCE LIGHTING

Generally, you must work with large-source lighting when it occurs naturally. It is impractical to try to change its effective size.

Large-source lighting from an overcast sky is usually easier to handle than light from a small effective source, such as direct sunlight. You don't have to worry about exposure problems due to bright areas and dark shadows in the same scene. Instead, the large source fills shadows with light, making them almost as bright as other areas. When using color film, be sure there is something colorful in the scene to make the composition seem lively.

EXPOSURE FOR OVERCAST SKY

On a cloudy day, the whole sky is the effective light source. Though it may not look bright, there is unlikely to be anything around that is brighter. Like blue sky on a sunny day, too much cloudy sky at the top of the picture can fool a built-in camera meter.

Depending on the meter's sensitivity pattern, this bright area can make the camera think the subject is brighter than it really is. Exposure recommendations in this case tend to result in underexposure of the subject. A camera meter with a center-weighted pattern minimizes this problem. Check your camera's instruction book.

Usually, you'll get correct exposure by pointing the camera down to exclude much of the sky or moving closer to the subject. Make the meter reading, set the *f*-stop and shutter speed, recompose the scene, then take the photograph.

IMPROVING THE PICTURE

Consider these ways to improve photos made on an overcast day:

Color Contrast—Add a touch of very bright color. For example, if you are photographing people in an urban landscape, ask your subjects to wear bright clothes. They will probably be bright enough to improve an otherwise colorless picture.

Lighting Contrast—This is low in large-source lighting because shadows are not very dark and highlights are not extremely bright. There is little you can do to control lighting contrast when the sky is the large source.

If you use a large-source light indoors, however, you can use a reflector to make shadows brighter or you can block some light to darken shadows.

▼ Tonal contrast is high in this photo because the overcast sun is pictured. Exposure was based on the background sky. This makes the tree reproduce dark. Photo by Richard Tucker.

▼ Large-source lighting reduces the three-dimensional effect of a scene. It emphasizes shapes in the composition. Photo by John Garrett.

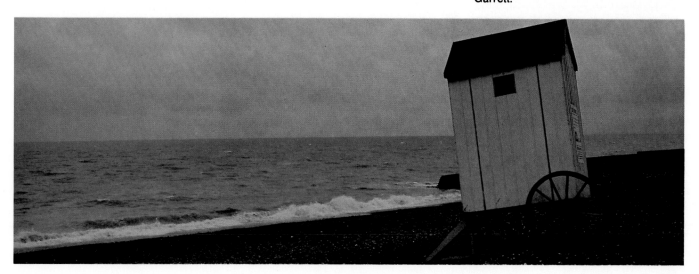

Subject Contrast—Subject contrast is the brightness difference between dark and light areas of the subject or scene, regardless of lighting. There are many ways to change it. For example, put a light-skinned person in light colored clothes against a dark background. The reverse is also practical.

Or, include a bright light in the picture, such as a street lamp, car headlamp or some bright reflection. This extends the overall contrast. If it is in the background it will add a feeling of depth. It may even give a bit of back lighting on the main subject.

Complexity—A complex scene is a problem with small-source lighting because shadows obscure details and shapes. Because large-source lighting illuminates all elements well, it can be an asset with a complex composition.

OTHER LARGE SOURCES

Two common large-source lights are artificial—an array of fluorescent lights on a ceiling and bounce flash. Besides the different color qualities of the lights, the major difference between the two is that you have much more control over the effect of bounce flash. Flash units are

▲ Large-source lighting suits the complex subject matter of this scene. Bright color contrasts are accentuated because the subjects do not cast strong shadows. Photo by Ron Boardman.

▶ Overhead fluorescent lighting, such as you find in stores, offices, and factories, is a common large-source light. Daylight color film reproduces this light with a bluish-green tint. Correct this by using filtration over the lens. Photo by John Bulmer.

available with tilting and swiveling heads, letting you turn the flash head at different angles to bounce light from ceiling, walls, or reflectors. Using flash this way is discussed later.

▲ For this scene, the sun was almost directly overhead. Notice the shadow. Reflected light from the sand also illuminated the subject. The sand acts as a large source, filling shadows.

LIGHTING ANGLE

Consider these positions for large-source lighting:

Top Lighting—A large source produces the same effect as shown in the seascape on page 15—good texture and modeling.

Front Lighting—To smooth skin tones and make the complexion of a subject look best, use large-source lighting. Texture and modeling are not usually desired. Spots and wrinkles are smoothed; noses lose their prominence. Only color and tonal differences remain—the eyebrows, lashes, pupils, nostrils and lips. Outdoors, achieve this sort of lighting by blocking direct sunlight.

SUMMARY

These are the important characteristics of large-source lighting:

Large Highlight—This is sometimes useful to show the shape of shiny objects. The highlight will not be strong unless the object is very shiny.

Soft-Edged Shadow Area—This helps keep the composition simple. It produces delicate modeling, color, and texture.

Very Soft Shadows—Shadows are so soft they are almost unnoticeable. This is characteristic of low lighting contrast. Shadows cannot complicate the picture, or be used to add contrast.

▶ On an overcast day at dusk, the sky acts as a large-source light with a blue cast. Here, a small bright tungsten light in the window provides color contrast. Photo by Richard Greenhill.

▼ This photo was lit by sky light in a shaded courtyard on a bright sunny day. Notice the slight blue cast. Photo by John Bulmer.

▶ Soft lighting flattens form and draws your attention to subject shape. Here, this effect is heightened by an out-of-focus background.

▼ Soft lighting tends to weaken color. In this case it produces a monochromatic effect. Photo by Suzanne Hill.

▼ Bottom: Spots of bright color counteract the effect of weakened color. If you cover the pink roses, this charming scene becomes duller.

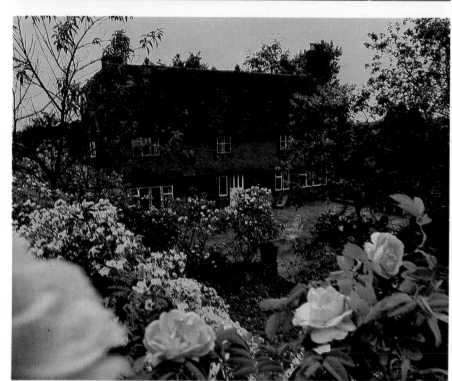

Medium-Source Lighting

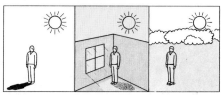

Small Source Medium Source Large Source

▶ The medium source for this photo was the open doorway and white wall. This makes shadows show some detail and depth. To be sure of a photo with a good balance between highlight and shadow detail, Anthony Blake made three pictures of this scene, each with a different exposure.

Some simple, small, or pale-colored objects benefit from small-source lighting. Some complex subjects need the simplicity of a large source. However, for the majority of subjects and conditions, *medium-source* lighting is best.

It gives some of the benefits of small-source lighting—such as showing texture and good color renditon—with some of the benefits of large-source lighting, such as simplicity and soft-edged shadows. It also contributes to good modeling for shape and a feeling of depth, scale, and solidity.

WHAT IT IS

A range of lighting effects is between large- and small-source lighting. But for the sake of simplicity, only one size—midway between the two extremes—is considered here. You can recognize a medium-source light by the soft-edged shadow areas. They are darker than the shadows characteristic of a large source and have softer edges than those of small-source lighting.

Medium-source lighting is defined in this book as a source approximately as large as it is far from the subject. For example, a window six feet square and six to twelve feet away from the subject is a medium-source light if no direct sun hits the subject.

WHAT IT DOES

Medium-source lighting gives excellent modeling for shape and roundness. The highlight is not so large and bright that it obscures the lit area. This gives relatively equal emphasis to the highlight, lit area, and shadow. The size of each depends on the direction of the light. A shadow due to a single medium source can be very dark.

Shiny Objects—If an object is shiny and round, a well-shaped highlight from a medium source can give an appearance of roundness. Shape and surface detail will also show well, as it will with non-round objects.

Matte Objects—The border between the shadow and lit area, which is important in showing shape and texture, is both well-defined and gradual. With small-source lighting, this area is often too abrupt. With large-source lighting, it is sometimes too subtle and vague.

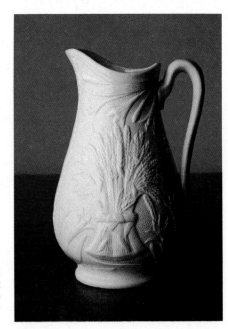

▶ Medium-source lighting gives good modeling of shape. Note the distinct but soft-edged shadows. Compare this photo with those on pages 20 and 26. Photo by Malcolm Warrington.

Medium-source lighting is ideal for matte objects. It shows a gradation of tones from lit area to shadow. This gives the impression of subject texture.

OUTDOOR MEDIUM SOURCES

Medium-source lighting is not common outdoors. If the sun is shining in a blue sky, it is a small source. When the sky is cloudy, the source is large. Medium-source lighting can occasionally occur when a black, thundery sky parts and allows a brilliant sunlit cloud to act as the effective source. The cloud acts as a giant floating reflector.

If you want medium-source lighting outside, you usually have to create it or look hard to find it. You may find it in shadows illuminated by a nearby surface reflecting direct light.

Changing a Small Source to Medium—Look for a situation where direct sunlight is blocked, so the subject is in shadow and a light-colored surface is acting as a reflector.

Alternatively, it may be possible to block the sunlight by using a beach umbrella, hat or similar object. Unless you are careful, the result will not be a medium source. If light is coming from the sky and surroundings rather than from one direction, the lighting is large-source. However, if a light-colored surface reflects directional light onto the subject, then you are using medium-source lighting.

You may find that only a small area within a scene is illuminated by medium-source lighting. For example, the overall scene is lit by small-source light from the back or side, but an area such as a face is in shadow, lit by light from a reflector. You can produce a romantic effect by basing exposure on the face. This makes the area lit by the small source relatively lighter than the face, which is correctly exposed.

Changing a Large Source to Medium—You can sometimes change large-source lighting from an overcast sky into a medium source by using large objects, such as a building or trees, to block some light and reduce the size of the light source.

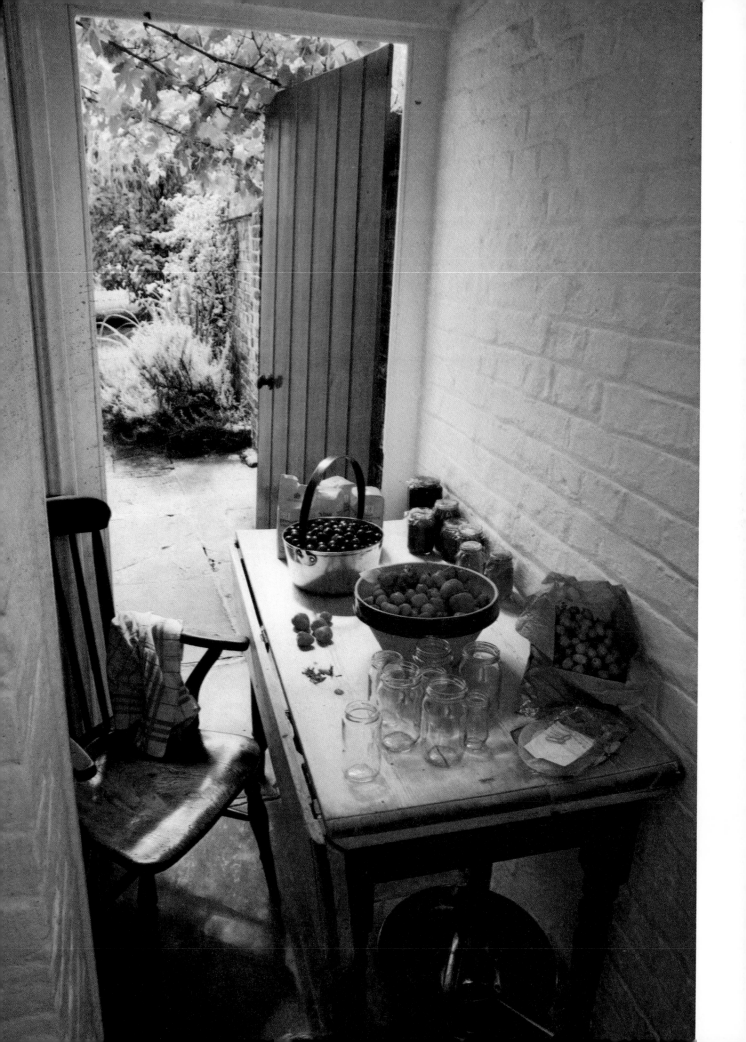

INDOOR MEDIUM SOURCES

Here the *amount* of the light is often a problem. Usually there isn't enough for a fast shutter speed or much depth of field. Even so, the quality of indoor medium-source light usually compensates for this problem. This is particularly true of diffused light coming through a window.

Natural Lighting—Diffused light coming through a window is usually medium-source lighting. The exception is a tiny window far from the subject. The window acts as a small source.

If you use color film, remember that light coming from the sky will be bluish. Eliminate this effect with a skylight, 81A, or other warming filter.

Shadow areas may be too dark. You can solve this problem by using a reflector or bounce flash to fill shadows with more light. A reflector will never fill shadows completely, but it can prevent them from becoming completely black.

Another way to brighten shadows is to open a door or pull back some curtains to allow light in from a different direction. If the sun is shining into a room and striking a white wall, the light reflected by the wall becomes a medium source.

Remember that if direct sunlight strikes a strongly colored surface, reflected light picks up that color. Depending on its intensity, it may give some shadow areas or the overall picture a color cast. To avoid this, use a white reflector.

If direct sunlight comes through a window, make the window a medium source by putting a diffuser, such as tracing paper, over the window. A white window shade or lacy curtains *may* give the same effect, or they may allow some direct, small-source sunlight through. The effect depends on the diffusing material.

To see if the lighting is medium-source or a combination of small- and medium-source, look at the shadows. If they have sharp edges, but are pale, the lighting is a combination. If they have soft edges, the lighting is medium-source.

Artificial Lighting—Indoor artificial lighting is usually not medium-source lighting. Fluorescent lighting is large-source if there are several fixtures. Most tungsten lighting is small-source or a combination of small and large.

Some large lampshades may help create medium-source lighting. The same is true of lamps designed to bounce light off a wall. The problem with these sources, however, is that the light level is usually low. In addition, the tungsten bulb usually used in the lamps has a color temperature

lower than 3200K. If you use daylight or tungsten film, the picture has a warm cast. Sometimes, this is OK.

For these reasons, many photographers create medium-source lighting with special lighting equipment. This includes special white or silver reflector umbrellas and large frames covered with diffusing material.

A simple way to produce medium-source lighting is with on-camera flash bounced from a large surface. It is often the most practical solution. Some flash units come with a white bounce card that you can attach to the flash head. Although this creates a larger effective source than that of direct flash, it is not big enough to give the same lighting quality as flash bounced from the ceiling. The exception to this is if the subject is within about 3 feet (1m) of the flash. Remember, the larger the reflector, the softer the resulting light.

Some people think that by putting a handkerchief or paper tissue over the flash, noticeably softer light results. This diffuses the source a bit and reduces the light level, but it does not make the source

appreciably bigger. Only a bigger effective source produces softer light.

SUMMARY

These are the important characteristics of medium-source light:

Medium-Sized Highlights—These are ideal for showing shape of shiny objects. Compared to a large source, there is less color loss due to desaturation in the highlights. Compared to a small source, there is more loss of color. If color saturation is important, using a smaller source may be necessary.

Moderately Soft Shadow Edges—This produces full, rounded modeling on matte objects. The texture produced is less than that from a small source. When texture is most important, a smaller source may be necessary. Conversely, for very complex subjects, or to subdue texture, a larger source may be best.

Soft-Edged Shadows—These give a good impression of the size, scale, and depth of the picture elements but are not so strong as to compete with the lit part of the subject.

▲ Look at the wooden egg to see how the full range of tones and the soft-edged shadow convey form. Photo by Michael Boys.

▶ Shadows indicate the nature of the light source. Although shadows in this picture are weak, they have a distinct edge. This lighting is a combination of small and large source from a partly cloudy sky.

▲ Richard Greenhill diffused direct sun by putting tracing paper over the window. This changed a small source to a medium source.

▼ Medium-source lighting coming through the window at left produces high lighting contrast. To reduce lighting contrast, use a reflector to put light in the shadows. Photo by Clay Perry.

Photographing into the Light

For most of us, the first photographic advice we hear is to keep the sun behind your shoulder. This is to give the subject good modeling and to keep exposure metering simple. It also avoids flare caused by shooting into the light source.

If photographs could be made by following a book of rules, anybody could make a great photograph. Photographer Edward Steichen once said that there are only two problems to be solved in photography—to capture the right moment when you release the shutter and to conquer light. One step toward the second goal is to disregard the "rules" occasionally. This sometimes means taking pictures while facing the light source. This is using *back lighting.*

SHOOTING TOWARD THE SUN

Depending on the relationship between elements in the scene, shooting toward the sun can make the subject appear very dramatic with a feeling of depth and rich tones. For example, a picture of flowers in front of the light may have strong colors because the light reflected from the surfaces of the leaves and petals is minimized.

Shooting into the sun can cause problems. *Never look at the sun through optical equipment. Irreversible damage to your eye may result.*

A subject in outdoor shadow is lit by skylight, which is very blue. We don't notice this, but daylight-balanced color film reproduces these areas with a blue cast. If you use color negative film, the lab can usually correct this during printing. With color slide film, however, you should make the color correction by using a skylight filter over the lens. Two types are available—1A and 1B. Both are slightly pink; the 1B color is darker than the 1A. They absorb the excess blue of skylight and reproduce colors closer to the way they look to you.

Image degradation may be caused by flare. This is unfocused, non-image-forming light. When you point the lens at a bright light, multiple reflections inside the lens may create *ghost images* of the lens aperture. You may also find that there are lines of light radiating from them. Light scattered inside the lens tends to lower image contrast.

DIFFRACTION ACCESSORIES

It is possible to turn this potential defect to advantage with *diffraction* lens accessories. These accessories look like filters and they fit over the lens like one. However, instead of absorbing light like a filter, they *diffract*, or bend, light.

◀ The light source for this photo is in front of the camera but slightly to one side of the subjects. This creates a *rim-lighting* effect on the right side. Photo by John Garrett.

▶ In this picture, light is transmitted through the translucent leaves. This results in a more dramatic photo than one made with the more conventional over-your-shoulder lighting. Photographer Timothy Beddow slightly underexposed slide film for dark, saturated colors.

▼ By shooting toward the light, you can make the main subject stand out in bold contrast to the shadow areas in the foreground. Photo by Homer Sykes.

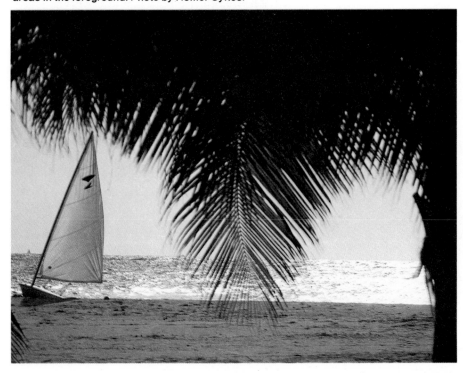

The glass or plastic accessory has fine lines etched or molded in a geometric pattern. Depending on the design and pattern, the lines have various effects. Some exaggerate the radiating lines from lens flare. Others diffract the light into bright rainbow colors, which can produce beautiful and dramatic results on backlit subjects. Still others turn highlights into star- or cross-shaped patterns. When using these accessories, try to superimpose the optical effect over dark parts of the scene. Otherwise, bright subject areas may wash out the pattern.

DETERMINING EXPOSURE

One of the biggest problems with back lighting is exposure calculation. This is es-pecially difficult if the subject is a landscape and the sun is low and visible in the view-finder. The camera meter will see direct light from the sun and "think" the scene is much brighter than it really is. Therefore, it will recommend an exposure that reproduces the landscape too dark.

The landscape is lit by reflected light and skylight, which is of lower intensity than direct light from the sun. Therefore, to reproduce detail in the landscape, expose *more* than the meter recommends. This is a general guideline for photograph-ing backlit subjects. How much more exposure to give depends on the camera meter's sensitivity pattern, how much direct light you are imaging, and how much detail you desire in the main subject.

To reproduce subject detail, exclude the effect of the direct light by metering closer to the subject, metering while pointing the camera down, or turn around with your back to the sun and meter from an average subject. When in doubt, bracket with more and less exposure.

INTERIORS

When you take pictures inside you can exercise a considerable degree of control over the light source. Consider creative techniques of shooting into the light.

If you use the back light as the main source of light, you may want to reflect some of the excess *spill light* back toward the front of the subject. Use colored reflec-tors to create various effects. Try locating

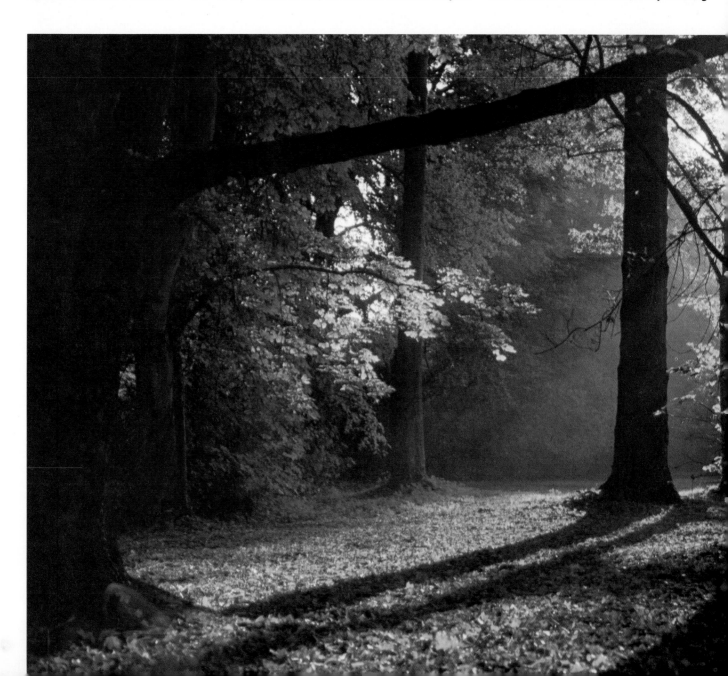

the source behind the subject, but not directly behind.

If you don't want light reflected on the subject, use black cards to limit spill light. Or, you can use special lighting accessories to limit spill light.

Exposure metering can be tricky. Remember, you must decide what part of the subject should be reproduced with detail. If you want a silhouette of the subject, meter the light and exclude the subject when metering. If you want the subject to be visible, meter the subject and exclude the effects of the light. For an in-between effect, use an in-between exposure. Bracket for best results.

Although back lighting provides a set of problems, some understanding and experience makes them solvable. Be willing to

▲ The sun was just outside the picture area in these photos. No flare is evident at top because a lens hood was used. Notice how flare reduced image contrast. Photos by Michael Busselle.

LENS FLARE

When light shines directly into a lens, surfaces of the lens elements reflect the light source numerous times. These multiple reflections become *ghost images* of the lens aperture or an overall *flare*. Ghost images are recognizable geometric shapes on the film. Flare is unfocused light that exposes film. It lowers image contrast by putting light into the shadow areas and obscuring image detail. These portions of the image reproduce with less density than you normally expect.

This problem is partially solved in *multicoated* lenses because reflections are greatly reduced. In addition, you can use a lens hood to prevent extraneous light from striking the front element. Even so, flare and ghosting may still occur. It happens most often with lenses with many lens elements, such as zooms.

To see the effect of flare, point an SLR toward, *but not at*, the setting sun. See how various shooting positions create different effects. View scenes at different lens apertures by using depth-of-field preview.

Sometimes, lens flare can improve a picture by giving a soft-focus effect or by lowering the contrast in a contrasty scene.

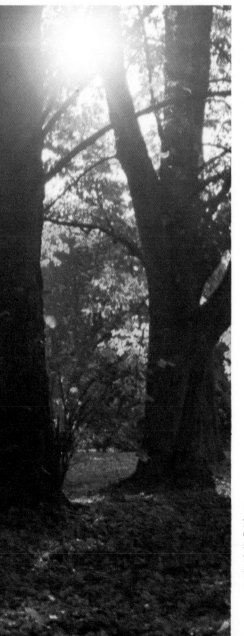

◄ This type of lighting is naturally high in contrast, but the resulting flare in this case counteracted the effect. Light spreads into the shadow areas. This contributes to the soft-focus effect. Clive Sawyer determined exposure by excluding the sun from the metered area.

▶ Working in a studio gives you control over the lighting effect. John Garrett used strong back lighting to outline the girl's head. To bring out subject detail, he used front light from a large source.

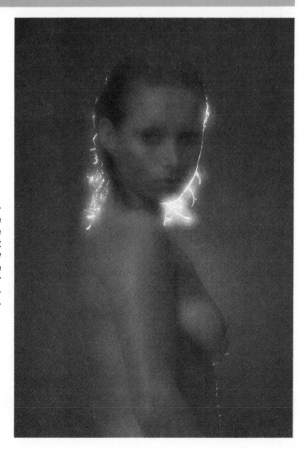

try new things; experiment; break conventional rules. You'll be rewarded with some outstanding pictures and effects.

SUNSETS

Sunsets are popular subjects. Here, *sunset* is defined as any time from two hours before the sun sinks below the horizon until about 30 minutes afterward. During this time, the light level decreases rapidly. This means you should check exposure often.

Metering sunsets is never easy. To reproduce the sky in middle tones, meter it. This will silhouette the foreground, and in many cases give good results. Recognizable objects, such as famous buildings, benefit from the simplification that a sunset silhouette gives, allowing you to concentrate on shape and pattern. Use exposure to *control* this effect. If you want the sky lighter, give more exposure. If you want it darker, less exposure. Bracketing is recommended when you want to be sure of getting the best picture.

When you look at sunsets, you'll notice that as the sun sinks lower, its light becomes redder and the sun appears to grow larger. A long-focal-length lens gives an effective sunset photo by compressing perspective and making the sun look like a huge red ball dwarfing foreground subjects. A wide-angle lens makes the sun seem smaller relative to the foreground.

▼ Sometimes, the most spectacular moment of a sunset is seconds before the sun disappears below the horizon. Photo by Timothy Beddow.

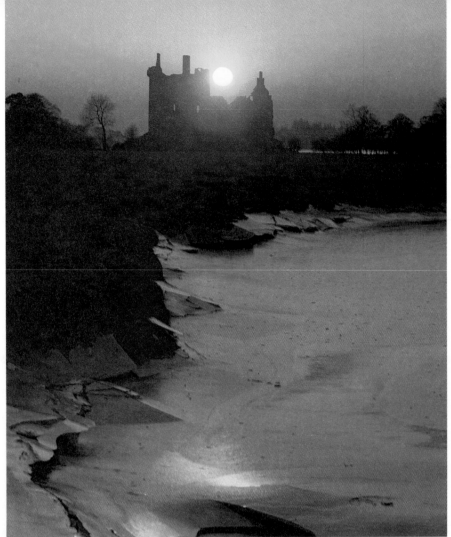

▶ A dramatic silhouette and a reflection of the sun in the foreground turned an everyday sunset into an extraordinary photograph. Photo by David R. MacAlpine.

Below right: As the sun sets, it seems to become larger. One of the most effective ways to capture this in a photograph is to use a long-focal-length lens. If the sun is also slightly out of focus, as it is here, the unsharp outline will make it appear bigger still. Photo by Alexander Low.

How to Use Side Lighting

Although lighting by the conventional over-your-shoulder method may seem to be a universal recipe for good photography, you have already seen that other lighting angles can give impressive results.

Over-your-shoulder lighting is *front lighting*. It produces a flattening effect that fails to bring out textural detail or provide an impression of depth.

For a two-dimensional photograph to give an impression of the subject's form, depth and texture, the light illuminating the subject should strike the subject from the side. This is called *side lighting*.

LIGHTING ANGLES

Look carefully at a brick wall in front light and then in the side light of sunset. Front light shows the pattern of bricks and mortar in a flat, uninformative way. As the light moves toward the side, the light emphasizes texture because each little bump or depression has a shadow. This effect is maximized when the light direction is parallel to the wall. This can give a photograph a three-dimensional look.

Side lighting is particularly important with b&w photography, which relies on tonal rendition rather than color to record the subject. Shadows due to side lighting reveal form and texture. Anything that has a noticeable texture gains visual impact when lit from the side.

USING SIDE LIGHTING INDOORS

Side lighting is suitable for most still-life and close-up subjects. The textures of flowers, fruit, or embroidery show up best with side light.

Indoors, you can create side lighting with either photofloods or a flash used off-camera and connected to an extension sync cord. Use an ordinary tungsten light as a modeling light for flash. Angle it until the shadows work best with your subject, then place the flash in the same position.

◀ Side lighting accentuates subject texture and produces long shadows for a three-dimensional effect. Front lighting can't do this. Photo by Helen Katkov.

▶ Michael Burgess made this photo from directly above. Low afternoon sun illuminated from the side. With close-up subjects, side lighting is useful to emphasize small textures that add interest to the picture.

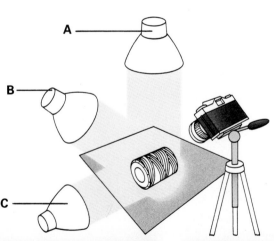

SIDE LIGHTING FOR TEXTURE

To demonstrate how side lighting shows subject texture, Malkolm Warrington positioned a light source at three angles relative to a spool of string. Camera position was the same in each photo.

A) With overhead lighting, the subject looks like a rectangle on a smooth surface.

B) This photo was made with the light at a 45° angle to the subject. Texture is more distinct.

C) With the light from one side of the subject, texture is very strong. The larger shadows make the string look rougher and reveal the texture of the background.

With flash, extreme side lighting can result in too much lighting contrast—the shadows may be too dark when you expose for the lit areas. Lighten shadows by using a reflector to bounce some of the flash into shadows.

USING DAYLIGHT

All lighting from a small source is directional. If it comes from a bulb or flash, you can control the angle at which it strikes the subject. However, the only way to control light from the sun is by choosing the time of day or time of year to photograph the subject.

When asked to photograph a house with natural light, an experienced photographer will scout the location first to find the most suitable time of day for each photograph. He will also wait until weather conditions are right. Not everyone can take the time to wait for this kind of perfection. But an understanding of how natural light affects any subject will help you get better results.

Of course, the best times of day for side lighting are early morning and late afternoon. As the sun sinks lower, shadows cast by the subject become longer. In winter the sun travels in its lowest arc across the sky, so light on a sunny winter day may give side light for a long time in the morning and evening. In spring and fall, the sun is higher in the sky. The summer sun is useful for side lighting in early morning just after sunrise and early evening just before sunset.

▶ Strong color is the most striking feature of this image. Dark shadows contribute to the impact by providing color contrast. Photo by Ed Buziak.

▼ This monochromatic photo is made interesting by the effect of side lighting. Photo by Patrick Thurston.

▶ Like the contours of a landscape, those of the human body are accentuated when lit from the side. For this photo, John Garrett used a soft-focus lens accessory and a black backdrop.

Shadows cast by a side-lit subject give the picture texture and relief. With color photographs, shadows seem to modify color on different subject planes so the picture has the impression of form and depth.

PROBLEMS & SOLUTIONS

There are few potential problems in using side light outdoors. Flare is one. Avoid this problem by using a lens hood.

Another is the color of the light. Daylight-balanced color film reproduces early or late sunlight as more orange than midday sun. Usually, this extra "warmth" improves the picture. But if you prefer to eliminate it, use a blue 82A filter or the equivalent over the lens. This will balance the color of the light to the color sensitivity of the film.

For outdoor portraits, side lighting gives strong modeling of your subject. If the modeling is too strong and the shadows too dark, you may wish to use a reflector or fill flash to lighten the shadowed side of the face.

EXPOSURES

With strong side lighting, the lighting contrast between highlight and shadow

areas may be too great for the film to record. If you expose for the highlights, the shadows may reproduce black. If you expose for the shadows, the highlights "burn out" and reproduce too light. Either way you may lose important image detail.

As a general guide, highlight detail is usually more important than shadow detail. Meter and expose for the bright areas. If you want some detail in the shadows and can sacrifice some in the highlights, use an exposure midway between those for the highlights and shadows.

MEASURING LIGHTING CONTRAST

You can measure the lighting contrast of a scene. What you do is meter the light on the lit side of the subject. Then meter the light in the shadow. Be sure to meter from similar subject tones, such as the skin in the photo at right. The difference between the two readings in exposure steps can be expressed as a ratio called the *light ratio*. High light ratios imply contrasty scenes; low light ratios imply the opposite. For most portraiture, low light ratios, such as 1:3 and smaller are used.

Difference in Exposure Steps	Light Ratio
0	1:1
1/3	1:1.3
1/2	1:1.4
2/3	1:1.6
1	1:2
1-1/3	1:2.5
1-1/2	1:2.8
1-2/3	1:3.2
2	1:4
2-1/3	1:5
2-1/2	1:5.7
2-2/3	1:6.3
3	1:8
n	$1:2^n$

▶ This still-life of three toadstools shows how side lighting and shadows can give the viewer more information about the subject. In this top view the toadstools themselves do not indicate how tall they are. The shadows show relative sizes and shapes. Photo by Eric Hayman.

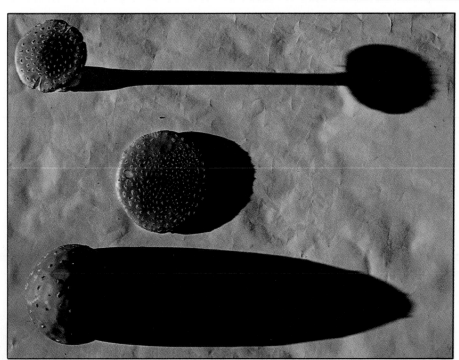

◀ Side lighting accentuates bone structure and facial features. Because side lighting also shows skin texture well, reserve it for male portraits. Photo by Lief Ericksen.

▼ Successful architectural photographers know the best time of the day to take photos. Often, this is when side light strikes the building. Photo by Ed Buziak.

Emphasizing Form

Photography shows solid, three-dimensional objects on a flat, two-dimensional surface. This means that the impression of *form*—or three dimensional shape in a picture—is an illusion.

What contributes most to this illusion is the interplay of light and shadow on the subject. The subject is bright where its surface faces the light source. Areas facing away from the source are shadowed. Areas at an angle between these extremes have an in-between brightness. These areas are most important.

By observing them, we can understand the subject's shape. With a directional light source, pale shadows that gradually get darker indicate gently sloping surfaces. Hard-edged shadows show a sudden change in direction.

To emphasize the subject's form, keep the lighting simple. More than one light source may lead to some confusing cross-shadows.

Two other vital factors in emphasizing form are the angle and size of the light source.

THE SIZE OF THE SOURCE

The best light to use for emphasizing form is a large source, as described earlier. The broader the light source the gentler the progression from lit to shadow areas. A small light source—like the sun on a clear day or a narrow spotlight—creates a change that is too abrupt.

When using artificial lighting, you can control the size of the source relatively simply. With either tungsten lights or flash, you can use a variety of reflector housings to create beams of different sizes. Consider bouncing the light from a large white surface such as a ceiling or

▶ The smooth surface of these rocks would look flat in overhead light. The setting sun accentuates the undulations of the rocks, showing their form. Photo by Lawrence Lawry.

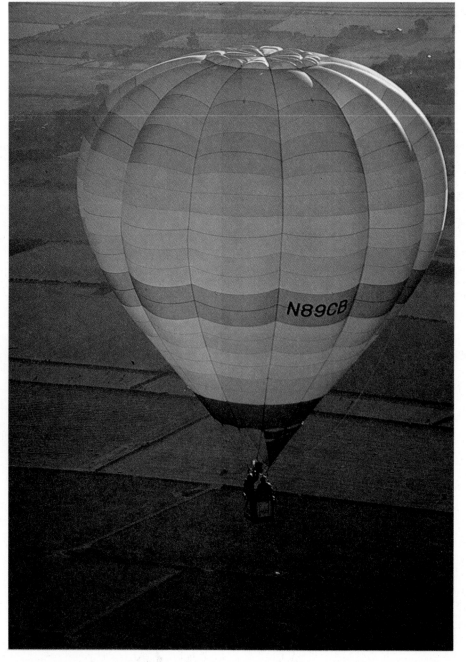

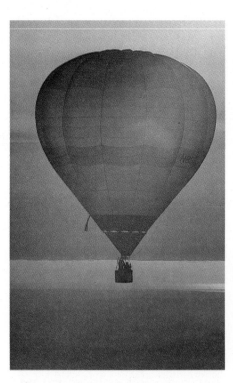

▲ Proper lighting is crucial to show subject form. Here, low backlighting from the evening sun shows mostly the balloon's outline. Photo by Remy Poinot.

▶ When the sun is higher in the sky and on one side, form becomes more obvious. Here you can see each curved panel of the balloon. Photo by Remy Poinot.

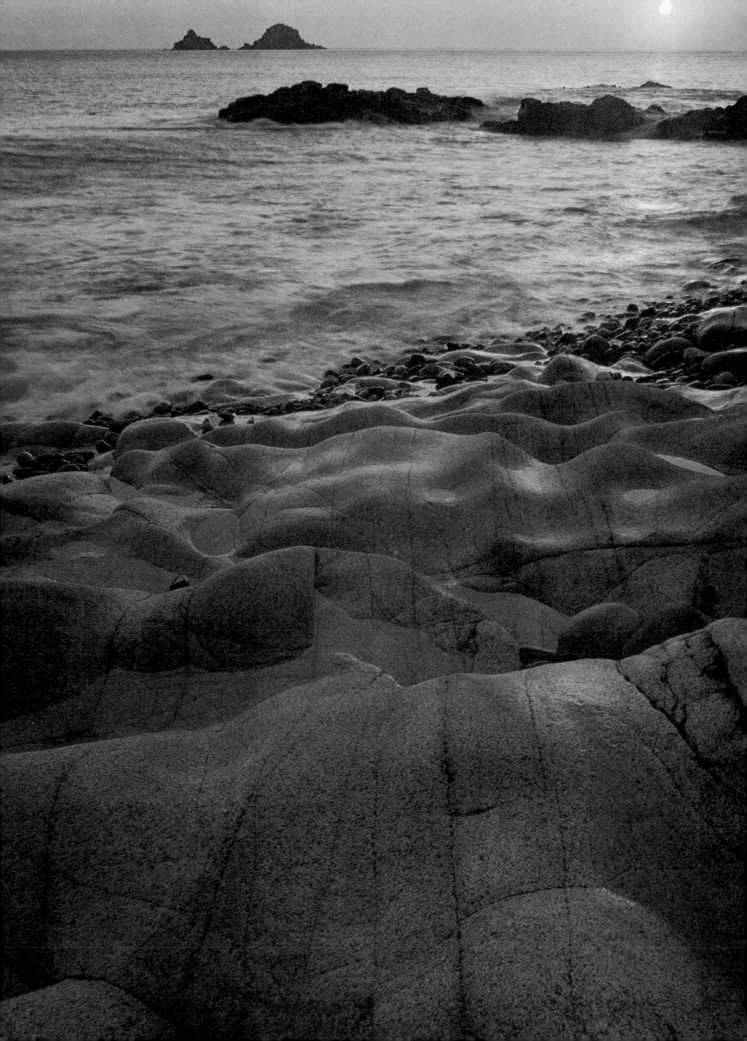

wall. Another way is to place a diffuser between the light and the subject. To significantly increase the size of the source, make the diffuser large and put it halfway between light and subject, or closer to the subject than the source.

For large-source lighting outdoors, high clouds or light fog are best for emphasizing form in natural light.

You can simulate these conditions by using diffusing material between the sun and subject. Obviously, the size of the subject determines the size of the diffusing material you need. It's not very practical to try diffusing the light striking a landscape. With smaller subjects, however, consider using cotton sheets or inexpensive muslin between the subject and the sun. This can be very effective with people or smaller subjects.

When photographing indoors by natural daylight, put diffusing material such as curtains or some white fabric over the window frame. The effect this creates is usually more pleasing than direct beams of light coming through the window.

THE ANGLE OF LIGHT

The other crucial element in emphasizing form is the angle of the light. In this book, the *lighting angle* is defined as the angle between the source and the optical path from lens to subject, also called the *camera-to-subject axis.*

You can easily see how lighting angle affects the scene by using a small object and a light. Place a white ball close to moderately strong window light. Walk around the subject and make some observations.

Look at the ball from the same direction as the light source, making sure your shadow does not fall on the ball. When viewed with front lighting, an angle of 0°, the ball appears as a circular patch of

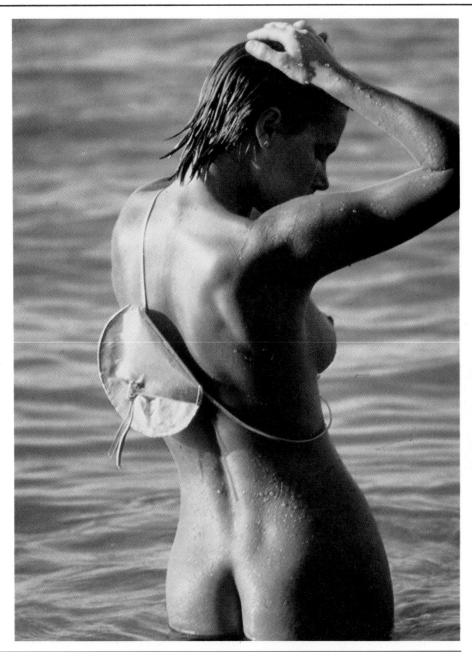

LIGHTING TO EMPHASIZE FORM

Far Left: Photographer Vincent Oliver used direct flash to light the model from camera position. The shadow falls behind her so the areas we see are evenly lit with little modeling. They look flat.

Left: Then he reflected flash using a white reflector placed on the right. Increasing the size of the source and changing the lighting angle shows more of the subject's form. Well-lit areas change gradually into shadow, clearly showing roundness.

white. The shadow is directly behind the ball.

As you move around the ball, the lighting angle increases and you see more of the shadow area. When the lighting angle is 90°, the shadow is prominent and on one side of the object.

When the ball is directly between you and the light source, the part you can see will be in shadow. This emphasizes the outline rather than solid form. This is one effect of back lighting.

The same thing happens with rectangu-

◄ To show form, look for light that falls at 45° to the camera-to-subject axis. The subject is lit by quarter light. Photo by Andreas Heumann.

▼ Glossy highlights and deep shadows under the cherries give a strong feeling of roundness. Photo by Sanders.

lar objects, though the areas of light and shade are more strongly separated because of the sharp angles between surfaces.

The best lighting angle to show form is approximately midway between front and side lighting. This angle is about 45° to the camera-to-subject axis. This will give a round object more lit areas than shadows around the surface, but still enough shadow to show form clearly.

BACKGROUND SHADOW

Another indication of an object's form is the shadows it casts on the background. Although dark, angular shadows indicate the position of the subject relative to the light source, they can be very distracting or confuse the impression of form. And, if front lighting is used to hide the object's shadow, the object seems to float over the background rather than be in contact with it.

The successful use of shadows to indicate form depends on the angle and size of the light. A dark shadow around the base that softens gradually into the background makes the object appear to be sitting solidly on its support. For this effect you need a large light source. If the light is behind the object, the shadow may be too dark and long. If it is angled from the front or from directly above, there may not be enough shadow to create the impression of form.

When we look at an object, we *know* it is real and solid, with a definite form. But this is not always clear in a two-dimensional image. Train yourself to notice the way light and shadow reveal form. Translate the information into the photograph. If you can't change the lighting, change the position of your subject. If it can't be moved, position yourself so the light is falling on your subject in the way that best emphasizes form.

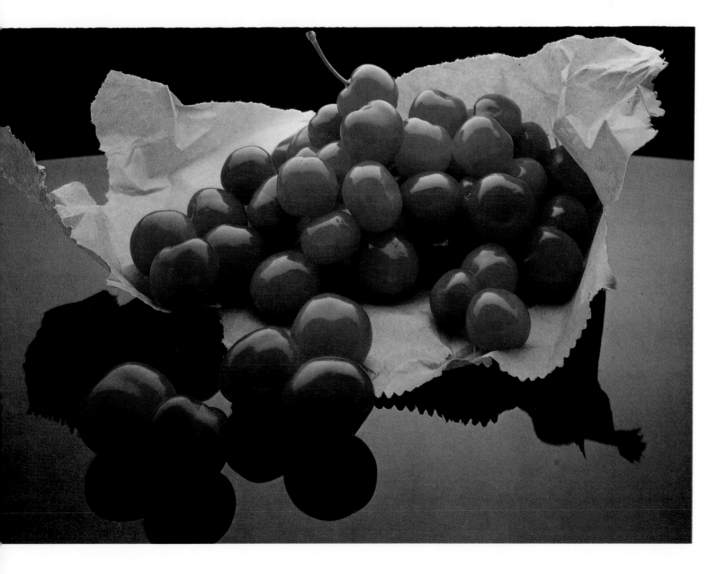

The Importance of Shadow

Shadow is an important, though often neglected, element of composition. When used carefully and creatively, it not only contributes a sense of depth and form, but may also provide an additional element to complement the picture's main subject. Shadows are so important that you should consider them as carefully as the main subject when you compose a picture.

SEEING AND RECORDING SHADOW

Our eyes have a remarkable ability to cope with an extreme range of brightnesses. We can see detail in both bright sunlight and deep shadow. The difference between the light level in bright and shadowed areas is the *brightness range*. The human eye works well over a brightness range about 1000 to 1—we can see highlight detail that is 1000 times as bright as the darkest detailed shadow.

B&W Film—When b&w film is exposed and processed normally, it "sees" a brightness range shorter than we do. Typically, it records a range of 128 to 1. This range is seven *f*-stops or exposure steps. This is called the film's *exposure range*.

B&w film does not record the range of exposure steps of detail that we can see. However, this is not as bad as it sounds because most scenes, called *average*, have a brightness range of seven steps. A scene with a longer range is one with dense shadows and bright highlights, such as a landscape illuminated by direct sun.

In addition, you can adjust the reproduction of the scene's brightness range by careful control of negative exposure and development.

Color Film—Color negative film has an exposure range of about seven steps when exposed and processed normally, but when printed, the effective range is reduced to about five steps. Color slide films have a range of about six steps. Adjusting the exposure range of color film is not practical with development controls. Therefore, when using color films, exposure is the best way to control shadow emphasis in the final image.

USING EXPOSURE

The way shadows reproduce on film depends on exposure. This allows you to control and exploit the significance of the shadow in the picture. In this way, exposure becomes an element of composition. As already mentioned, a long-range scene on film sacrifices image detail. When you expose film, you should sacrifice detail on purpose, not accidentally.

◄ These two pictures show the difference between shadows in color and b&w. Because color transparency film has a shorter exposure range than general-purpose b&w film, shadow areas usually appear darker and have less detail than those in b&w. You can control this effect in b&w photography if you process and print your own pictures. Photos by Michael Busselle.

► These photographs illustrate the difference that exposure makes to the relationship between shadow and highlights. The shadows on the woman's face in the top picture are almost black, producing a near silhouette. This exposure is "correct" if the glass is most important.

The picture below received one step more exposure, yielding more detail in the face and fingers. If the woman is most important, this exposure is "correct." Photos by Ron Boardman.

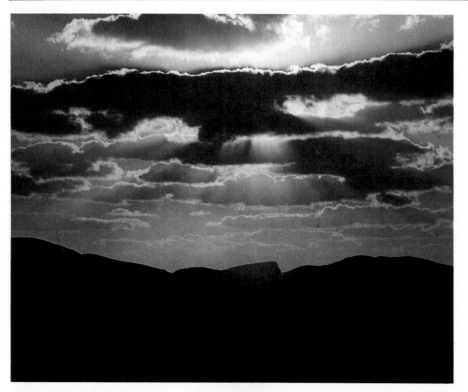

When most of the scene is brightly lit and the shadow areas are either small or contain insignificant details, base exposure on the brighter areas. Point the camera or move your location so the meter sees these areas only. Use the recommended settings, compose the picture, and make the exposure.

When most of the scene is shadowed and bright areas are small or unimportant, point the camera meter at the darker areas. Use the recommended settings to make the picture. In this case, the bright areas burn out.

If *both* shadow and highlight areas contain equally important detail and are about the same size in the scene, use a setting between highlight and shadow exposure. Usually, the camera meter will recommend such an exposure if you meter the composition you prefer.

Scenes lit by back light can be trickier to meter. If you want the foreground subject to silhouette, meter the light source. It reproduces as a middle tone, and the darker foreground reproduces black or very dark.

◄ By shooting toward the light and metering the background, you darken or silhouette the foreground due to underexposure. The background reproduces as a middle tone.

In the picture above, Adam Woolfit emphasized the shape and color of the clouds by suppressing unwanted foreground detail. For the picture at left, Michael Busselle created a simple, but dramatic, image by silhouetting the child.

► This interesting shadow pattern first attracted the photographer's attention. Timothy Beddow waited until he could include the figure and shadow of a passerby to make the composition more interesting. He based exposure on a light reading in the lit area.

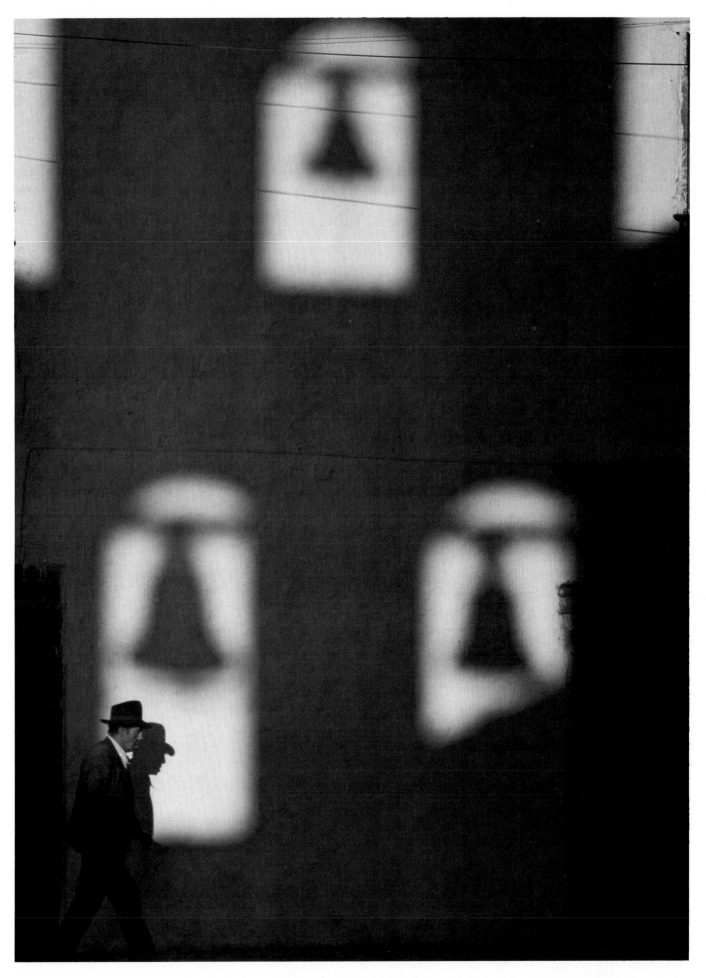

▲ A pattern of shadows from a tree super-imposed on the shape of the door created an abstract image. Photo by Anne Conway.

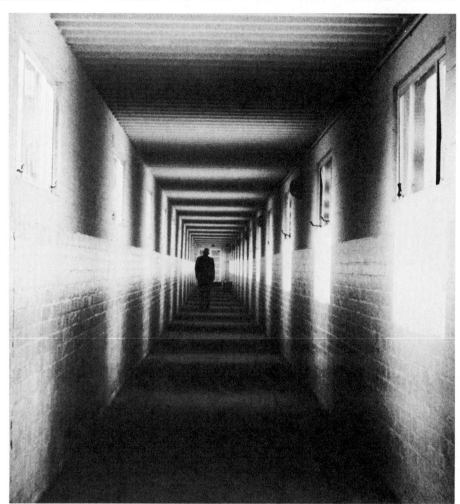

▶ Hallways and corridors often provide good opportunities to exploit unusual lighting effects. The strange shadows in this photo serve to strengthen the linear perspective and add to the feeling of depth.

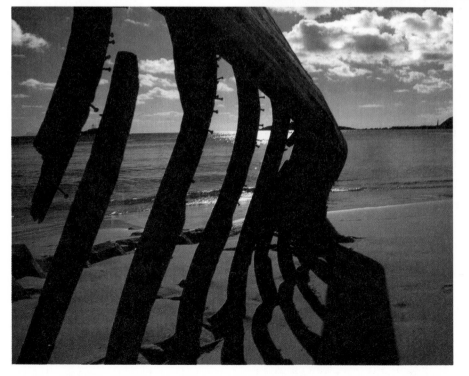

▶ Above right: By slightly underexposing the shadow of the girl in the deck chair, Steve Herr created a neutral setting to contrast with the richness of the color.

▶ A similar technique was used by John Sims for this fashion photo. By including so much shadow in the composition, he focuses your attention on the one bright spot in the picture—the red bathing suit.

◀ A deep black shadow cast by a silhouetted subject can appear to be attached to the object. Together they form a new shape. By choosing a low viewpoint for this picture, William Cremin created a strong graphic image.

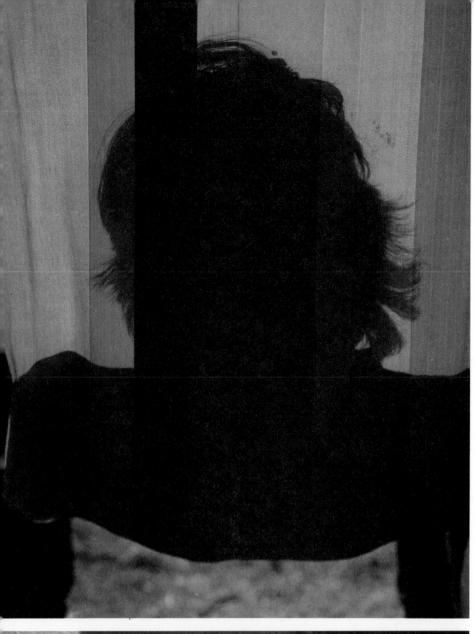

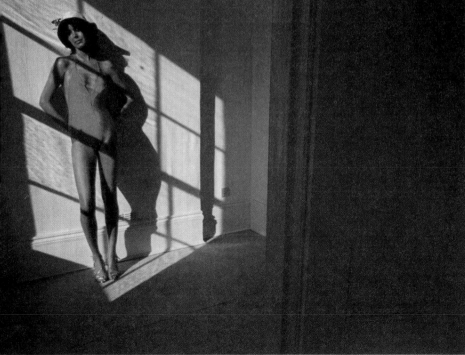

More exposure on the foreground lightens it in the picture, but will also wash out the background. Sometimes this is OK, such as when you want bright highlights on the hair of a person who is back lit. In this case, meter the scene with the camera meter, then set the lens for an extra one or two steps of exposure. Another method is to get closer to meter the subject itself, eliminating the effect of back light on the meter. Move back to include the back lighting in the composition and shoot.

If you are unsure of the effect you want, make more than one exposure, using different settings. For example, set the camera for the effect you like most, then make two more exposures for one step each of under- and overexposure. This is called *bracketing*.

USING SHADOW

When you expose for good highlight detail, remember that the image may have dark shadows with little, if any, detail. Consider this before exposure so you can use shadows as a design element. Before taking the picture, you can get an idea of the final result by squinting your eyes and viewing the subject. This effectively "underexposes" your vision. If your camera has a depth-of-field preview control, use it to stop down the lens. This will darken the viewfinder image.

The simplest way to use shadows is to support the main subject—such as emphasizing its shape and form, indicating time of day, the direction of the light, or even the kind of weather.

Usually the darker the shadow the more powerful the effect. But in color photography, a light shadow can accentuate a subtle range of hues not found in brighter light. So, look for *pale* shadows as well as dark ones. The important thing is to be aware of shadow in the first place. Once you have noticed it, the possibilities for its creative use are practically endless.

Also consider these aspects of shadows:
- Silhouetted shapes can add drama to a composition.
- Exaggerate shadow area to minimize the effect of unwanted foreground or background detail.
- Shadows provide a neutral setting to enhance the effect of bright color or to separate areas of conflicting color.
- Strong shadows can emphasize the brightness of a small highlight, such as a shaft of light falling through a break in the clouds.

Using Light and Shadow

Whether you photograph in b&w or in color, remember that the interplay between light and shadow is one of the most important elements in a picture. It is fundamental to the representation of form, which is what photography is about most of the time.

Preceding sections have discussed the effects of light *or* shadow—this one discusses how light *and* shadow work together.

CREATING FORM

When you photograph a subject with strong front lighting, such as with an on-camera flash, the image of the subject appears flat. This happens because the shadow is mostly hidden by the subject. If you move the lighting to one side, shadows will appear on the subject and other surfaces around it. The two-dimensional picture then implies form and appears to be more three dimensional.

This is why a picture of a landscape taken at midday, when the shadows are shortest, is often less successful than the same view photographed in the early morning or late afternoon when the sun is lower in the sky. In this case, shadows are more prominent.

Sometimes, you may want to create a flat, shadowless picture—for example, when the subject is full of complicated lines and patterns or when you want to record detail rather than shape or depth.

▶ Midday sun is not very effective with outdoor scenes. Because shadows are not evident, neither is form. Photo by Alfred Gregory.

▶ Below right: Because shadow areas are a large part of the composition, photographer John Sims wanted them to reproduce with detail. He gave slightly more exposure than the meter recommended. The trees and grass show detail and the sky washes out slightly.

▲ Photographer Chris Hill produced a flat, nearly shadowless image with on-camera flash. This emphasizes color but gives little form.

▲ The interaction of light and shade caused by side lighting gives the strong sense of form in this picture by Dan Budnik.

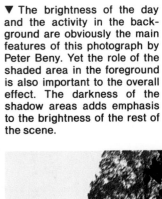

▼ The brightness of the day and the activity in the background are obviously the main features of this photograph by Peter Beny. Yet the role of the shaded area in the foreground is also important to the overall effect. The darkness of the shadow areas adds emphasis to the brightness of the rest of the scene.

▲ To imply the bleakness of the lives of peasants, Alexander Low pictured them in front of gloomy shade. Strong side lighting and their somber expressions set the mood of the picture.

▶ An equal proportion of light and shade in a picture is likely to create an ambiguous mood. However, as this picture by Anne Conway shows, the absence of mood is fine for an abstract image.

However, to record subject form, use a combination of highlight and shadow. This is especially important for showing subject texture. Conveying texture in a photograph depends almost entirely on the contrast between light and shadow.

BALANCE AND MOOD

When composing an image of a subject in contrasty lighting, consider the balance between areas of light and shade. Are shadow areas the same size as bright areas, or is one relatively larger than the other? This influences the mood of the photo.

Bright light usually appears white in a photograph and immediately attracts the viewer's attention. The blackness of shadow often records much darker than it appeared when you took the picture, so it can also demand viewer attention. Therefore, use it as an important design element. Obviously, the darker the shadow, the greater its impact.

With these ideas in mind, you can use the effects of light and shadow to offset each other. Consider a crowded beach on a sunny day, for example. To capture the lively atmosphere of the scene, the photo should be predominantly light and bright. A single area of strong shadow introduces an opposite feeling that may overpower or emphasize the vitality of the picture.

Conversely, the somberness of a shadowy interior can be exaggerated by the brightness of a small shaft of light. In this way the interplay of light and shadow becomes an important compositional element in picture making.

A photo with equal amounts of light and shadow may not create any definite mood, so keep the balance in favor of one element or the other.

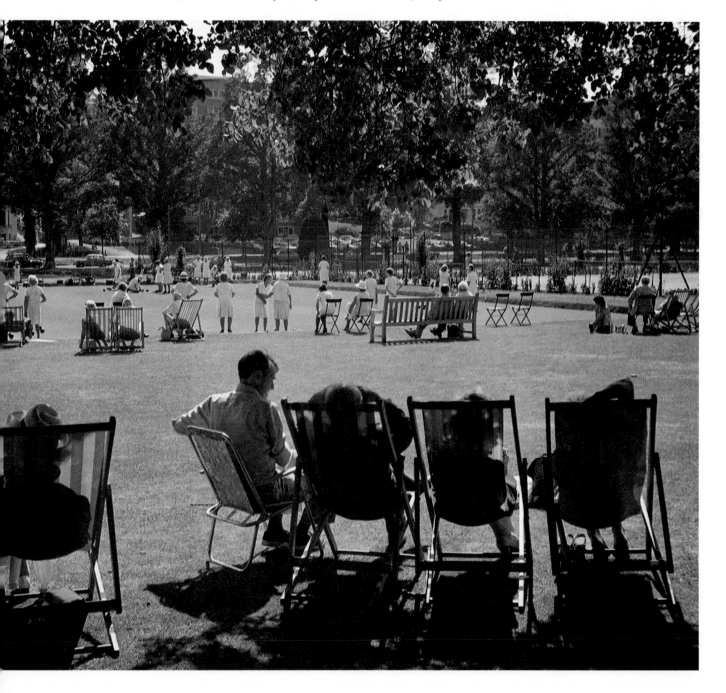

Increasing Contrast

Contrast is the relationship between light and dark tones. High contrast implies bright highlights and dark shadows. Low contrast is the opposite. In a photograph, contrast has an effect on form, distance, and mood.

If you can control contrast, increasing it sometimes adds impact to a picture. However, there are times when it is necessary to decrease contrast. This is described in the next section. There are three types of contrast to consider.

Lighting Contrast—As described earlier, this is the difference between the brightness of the lit area and that of the shadow area. It depends on the size of the source and its brightness. It *does not* depend on the subject or elements in the scene.

Subject Contrast—This is the relative brightness of elements in the picture if they are lit by the same light. For example, the tonal contrast of white and black objects in the shade is the difference in their brightnesses.

Tonal Contrast—This is the *combined* effect of lighting and subject contrast. It has also been defined as the *brightness range* of the scene. You can measure it by metering the brightness of the brightest subject tone in the brightest light and metering the darkest subject tone in the shadow area. The difference is tonal contrast, which is what you photograph.

CONTROLLING INDOOR LIGHTING

Increasing lighting contrast indoors is relatively simple. Adjust the distribution of the light by changing the position of the source relative to the subject. Remember, most indoor lights are small or medium sources.

▼ Medium-source lighting through a window was made more contrasty by a black board at the right. This reduced reflected light and produced darker shadows. Photo by Anthea Sieveking.

▲ ▼ The bird in the photo above seems more contrasty than the bird shown below. This is due to the differences in the lighting. Actually, the birds have very similar colors and markings. Photos by Suzanne Hill.

▲ These two photographs show how lighting contrast can be changed by moving the light, as shown in the drawings. Photos by Steve Bicknell.

▲ A snoot limits the lit area by narrowing the beam.

▼ This is a picture with high lighting contrast and high subject contrast. The result is high tonal contrast. Photo by Suzanne Hill.

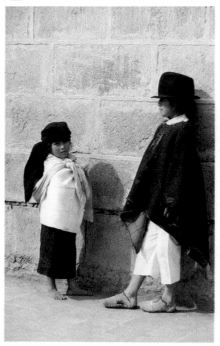

For example, you can put the light close to the edge of the picture to increase tonal contrast. Close lighting with a medium or small source creates an extreme brightness difference between one side of the picture and the other. The background is dramatically darkened, too, because it is farther from the light. The effect is more tonal contrast due to dark shadows and bright highlights. This technique is good when subject contrast is low.

In addition to positioning the source, you can control the light from spotlights and floodlights by using different reflector housings. A *snoot* is useful for cutting down the light area. It is a tube placed in front of a light to limit the beam to a smaller circle.

NATURAL LIGHT

When working in daylight, the lighting problem is usually one of too little control. Sometimes, the only control you have is to move the subject or wait for the light to change.

With small-source lighting from the sun, there are usually plenty of dark shadow areas you can use to increase tonal contrast. Small-source lighting is usually easy to block if you wish.

With large-source lighting, the subject casts pale shadows. In this case, you should consider increasing the subject contrast. Do this by including a bright object

in the scene if the subject is mostly dark. If the subject is mostly light, increase subject contrast by including a small dark object in the scene. This increases tonal contrast and helps create a full range of tones.

BACKGROUND

The tone of a background can affect your choice of lighting. A light subject stands out well against a dark background and a dark subject stands out against a light background. When the subject does not stand out, you should consider changing lighting or subject contrasts to increase the tonal contrast of foreground and background.

An example is a blonde child playing on a sandy beach. The problem is that skin, hair and sand are similar tones. You want the child to stand out well from the background. You can wait until the child moves to a part of the beach with a shadow area nearby. Or, find a way of casting a shadow over the child, such as with back lighting or a beach umbrella. If a large black dog happens to sit down behind the child, the dog becomes a contrasting background.

The difference in background tone or its size need not be great. A slight movement of the camera to one side or the other might line up the subject against a small contrasting area, so the subject stands out clearly.

▶ Far right: Subject contrast was increased by careful composition. If the subject were a little to the right or left, he would not have stood out as clearly against the background. Photo by Richard Greenhill.

▶ Light from direct sun on a clear day gives a high lighting contrast. Because the pale street reflects much light, it lowered the lighting contrast on the girl.

▼ Here, S. G. Hill made the boy stand out well by placing him in front of the dark doors.

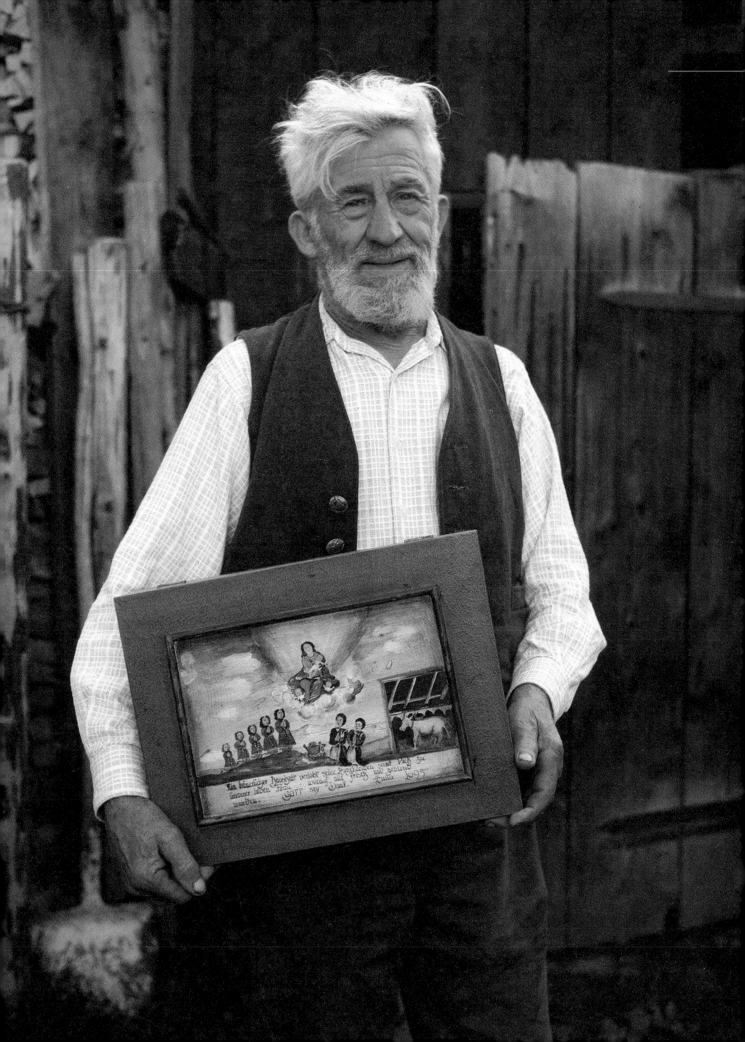

Decreasing Contrast

Many times you want to reduce contrast, such as when dark shadows are unflattering to the subject or because the film you are using cannot record both shadow and highlight detail in the scene.

When one small or medium source lights a scene without many reflecting surfaces to lighten the shadow area, lighting contrast is high. This happens when you photograph subjects in the open on a bright sunny day. However, there are usually some reflecting surfaces to fill shadows with light. The degree of this effect depends on the brightness of the reflecting surface. For example, white sand reflects more light than green grass. Therefore, when outdoors you can decrease lighting contrast on a sunny day through selection of the ground and surroundings.

LIGHT SOURCE AND SUBJECT

To lower tonal contrast—which is what you photograph—you can control either the lighting contrast, the subject contrast or both. If the subject contrast is high, such as a scene including eggs and lumps of coal, consider increasing the size of the source. This will lighten the shadow areas and let the subject's dark areas be darkest in the picture. Increasing the size of the source, such as with reflectors, is described earlier in this book.

Or, you could change subject contrast by darkening its bright areas or lightening its dark areas. Sometimes this isn't practical, but when it is, such as with the clothes a person wears for a portrait, this is an important control.

As described earlier, film records a limited brightness range relative to what we can see. This is another reason to know how to reduce excessive tonal contrast. The box at right illustrates three ways to do this.

THE SUBJECT AS REFLECTOR

You can lower lighting contrast by using reflections from objects *within* the picture area to lighten shadow. Look for light-colored areas of the subject that can be used as reflectors. For example, a hand or a book can be used to reflect light onto a face.

The color of a subject affects its response to lighting. Contrast between highlight and lit areas is greater for dark objects than for pale ones. The contrast between the lit area and shadow area is greatest with pale objects. A pale green apple might have a well-defined shadow and lit area, but a near-invisible highlight. A dark red apple in the same light would have a well-

▲ Exposing for the lit area.
▼ Exposing for the shadow area.

LOWERING CONTRAST

Here is an example of a typical situation in which tonal contrast is too high. Two children are playing in a room lit by daylight from an overcast sky coming through a window.

Little of this medium-source light is reflected by the walls of the room. The face of the child with his back to the window is in dark shadow, while the other child faces the light. Exposing for the lit area yields the photo above, which renders the shadowed subject too dark. Exposing for the shadows gives the photo below. This is a better result, but the skin tones of the lit boy are too bright.

There are three easy ways to solve this problem:
1) Lower lighting contrast by putting

more light in the shadows, as in the photo at bottom right. You can use a white or silver reflector, a white sheet, aluminum foil glued to cardboard, spread-out newspapers or a book.

2) Change the composition so shadows do not contain important subject detail, as in the photo at right. Wait until the subjects move or change camera position so the children are front lit. Shadow areas are now so small as to be negligible.

3) Place all important subject details in shadow and meter the shadowed area. Essentially, this increases the size of the source. See the example of the girl wearing the hat, page 69, center.

▶ Both faces toward the light.
▼ Books used as reflectors.

▲ If the singer had been lit solely by strong overhead lighting, most of her face would have been in shadow. However, the book she is holding reflects light back into her face. This light provides dramatic bottom lighting that helps separate the woman from the crowd. Photo by Nick Hedges.

defined highlight with the lit area merging into the shadow.

Go outside on a bright day and see how many natural reflectors you can find. Sand, light gravel, walls, the side of a car or a light-colored boat, water, a towel, a table cloth, a book, a newspaper and light clothing are examples of elements in a scene that you can use as reflectors.

The color of the reflector can affect the color of the subject. For example, the reflection from a green car may make your subject look unwell. Look carefully at reflections casting additional light on the subject. Even if *you* don't see them, color film may.

FILL LIGHT

The potential problem with using a second light source to reduce lighting con-trast is that it may interfere with the effect created by the first, or *main*, light. You do not want the fill light to eliminate the shadow cast by the subject. Nor do you want the subject to cast visible shadows due to the position of the second light.

To avoid the first problem, use a white reflector rather than a light. Reflected light will never be as bright as the main source. And, any shadow due to the location of the reflector is usually negligible.

If you use a lamp or flash as a fill light, locate it where the subject will hide the shadows it casts. The best way is to make the fill source a front light. In the case of flash, mount the flash on the camera. When using a tungsten light, place the light as close to camera position as possible.

◀ A bird feeder acts as a reflector to light the lower half of the bird, which would otherwise have been in shadow. Photographer John Walmsley suppressed the background details by limiting the zone of sharp focus.

▶ The woman's hat shades her from the harsh, overhead sun. The light illuminating her face is from reflective surfaces all around her. Subject contrast is unchanged; lighting contrast decreases.

◀ Contrast could have been too high here, but the subject has been carefully positioned. With the sculptor's face in shadow, his hands and work are emphasized. A reflector at right bounced some light into the face. Photo by Richard and Sally Greenhill.

Using More Than One Light

Sometimes, you have to use more than one light to photograph a subject well. This occurs most often indoors. The number, angle, and type of lights you need depend on the subject and the way you want the photo to look.

For example, a person reading a book while sitting at a table can be photographed in several ways, each presenting a different lighting problem. Lighting the whole scene is different than lighting just the person at the table. Photographing the hands requires a third approach.

Consider the overall effect. Should the room appear lit by window light or lamp light? Is the person young or old, male or female? Is the book serious or light-hearted? The lighting you use establishes the atmosphere and sense of place and time in the image.

SUPPLEMENTING DAYLIGHT

Suppose the room is to appear lit by sunlight coming through the windows. The simplest way to light it would be to use daylight through the window, with reflectors added to reduce the lighting contrast of this medium source.

If the day is overcast, you may need to use another light to give the impression of sunshine coming through the windows. If

▲ One main light shows form but also results in dark shadows. When exposure is based on the lit areas of the face, the background seems unnaturally dark.

▲ A second light fills some of the dark shadow areas. This second light is spread out by an umbrella reflector, which effectively increases the size of the light source. The photo seems more natural than the one at left.

you aren't going to include the window frame in the picture, then you can put the "window" light anywhere, regardless of where the real window is. This control is one advantage of artificial light.

Simulate a window by placing a light behind a large white sheet. For shadows similar to those cast by a window frame, suspend a cardboard cut-out in front of the diffuser sheet. Fill shadows caused by the simulated window light with a reflector or by bouncing a second light off a wall or ceiling.

SUPPLEMENTING ARTIFICIAL LIGHT

If the room should appear to be lit by household lighting, use a different approach. Place the strongest, or *main* light, high to simulate a ceiling light. This way the subject will cast shadows that look natural and familiar. Look at the shadows. How dominating are they? Do they seem to be in the right place? Move the main light around. Adjust its location and position until both shadows and highlights look right.

Then bounce a second light off the ceiling or wall so it illuminates the area behind the table. Try it with the main light

▲ A third light is pointed at the background to brighten it and make it part of the composition. Notice that the clock casts a dark shadow. If the third light were a larger source, the shadow would be softer.

▲ Instead of lighting the background, the third light was raised and turned to light the boy from the back. This is a good way to separate the subject from a cluttered or unimportant background.

turned off to see exactly where the fill light falls. Move the second light around, if necessary, for best effect.

When you turn on both lights, it may become apparent that a third light, such as a spotlight with a snoot, is needed to light the hands.

These are only a few examples of the many ways to light a single scene. After you decide on the effect you want, set up the lights one at time. Make each light contribute to the desired effect.

LIGHTING A FACE

For a picture of a face, you should start with one main light. Its position—usually high and to the left, right or center—is important. If you place the light too low, the subject will look ghostly. If it is too far to one side, only half of the face will be lit.

As a general guide, keep it above head height and at about 45° to the lens axis.

Remember that large-source light is usually more flattering than light from a small source. Small-source lighting tends to over-emphasize skin texture and show every pore and facial line.

For fill light, you may need only a reflector. If more fill is required to open shadows, put a light of lower intensity than the

▲ To emphasize only the hand, the main light was turned off. A light from the rear illuminates the hand and checkerboard. Soft light from the umbrella lightens dark shadows.

▲ Don't use too much light or the scene may look artificial. Strong highlights on both sides of the boy look unnatural. *Double side* lighting like this was once used for glamour photography. Photos by Michael Busselle.

main light as close as possible to the lens axis. This fills shadows resulting from the main light, and minimizes double shadows. If it is a fairly large source, it will also light the foreground. Look at the effect of the lights one at a time. Adjust them and then try both together. Make more adjustments if necessary.

Back Light—Point another light at the wall behind the subject. Or, it can be positioned to shine into the hair from behind. The head shields the camera and each hair shines like a halo. Make sure the subject does not have dry, fly-away hair—specular highlights produced by this lighting can make individual strands look like string. Slightly dampen hair, if necessary, to make it controllable.

SUITABLE EQUIPMENT

Two lights should be enough to start with. Choose medium large sources rather than small ones. Use lighting accessories such as snoots, barn doors, umbrellas, diffusers and reflectors to maximize the lights' potential.

For color, use the right film for the color balance of the light. For example, when using flash, use daylight-balanced film.

▲ For this lighting effect, Michael Boys used a main light, above and to the right of the subject. Soft fill light was produced by flash bounced from the ceiling. He used a pink filter over the lens.

For more information about advanced lighting techniques, see *How to select & use Photographic Lighting* by David Brooks, also published by HPBooks.

Mixing Flash and Daylight

Using electronic flash with daylight, also known as *synchro-sunlight*, is done for three reasons—to reduce lighting contrast; to improve color reproduction of shadows; and to create special effects.

The technique consists of metering daylight and selecting exposure settings that use a flash-sync shutter speed, such as 1/60 second or slower. See your camera instruction book or an HPBooks camera manual for your brand. Then, position the flash at an appropriate distance for the aperture set on the lens.

The focal-plane shutter of most 35mm SLR cameras synchronizes with electronic flash at shutter speeds about 1/60 second and slower. Some shutters that travel vertically sync at 1/125 or 1/90 second and slower. You *must* choose a suitable electronic flash sync speed when mixing flash with daylight. Otherwise, not all of the film will be exposed by flash.

CONTROLLING LIGHTING CONTRAST

Often called *fill flash*, this technique is used to reduce the brightness range of a contrasty scene. As mentioned earlier, a

◄ The inside of this hospital room was very dark compared to the daylight outside. To brighten the room and reduce lighting contrast, Julian Calder used three flash units in the room (top). This was not enough light to balance with the outside light. Outside detail is washed out. The only solution was to stop down the lens to slightly underexpose the interior (below). Detail is still visible, and outside detail is clearer. This is balanced lighting.

▼ The photo below left was made in available daylight when the light was dim. At right, flash was used with daylight to add detail in both highlight areas and shadows. Notice the color change due to the light from the flash. Photos by Ron Boardman.

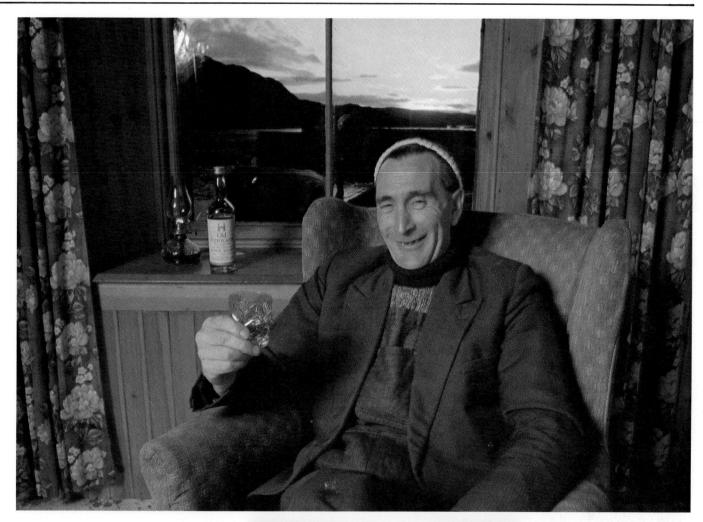

scene with bright highlights and dark shadows has a brightness range greater than the film can record. To avoid sacrificing shadow or highlight detail, or both, you can reduce the brightness range by putting more light in the shadows.

Use fill flash outdoors if the subject is not too large. For example, you may want to take a picture of a person and a colorful sunset in the background. If you expose in the normal way for good color rendering of the sky, the foreground figure will be underexposed. An exposure for detail in the figure will result in an overexposed, washed-out sky. In these circumstances, fill flash provides the ideal solution.

You want to use the flash to *supplement* the exposure due to continuous light from the sky and sunset. This means the flash should give less exposure than the continuous light to preserve its lighting effect.

Suppose the exposure setting for good exposure of the sky is 1/60 second at *f*-5.6. Use the flash guide number (GN) to find subject distance for an *f*-5.6 aperture:

GN/*f*-stop = subject distance

Suppose this calculation gives a subject distance of 10 feet for full exposure of the subject by flash. If you locate the flash at this distance to give good exposure for an aperture of *f*-5.6, the resulting photo may look unnatural. One solution is to keep the continuous-light exposure constant by using 1/30 second at *f*-8. This causes the

▲ It is important to preserve a natural lighting effect (above) when using fill flash to control lighting contrast. Control the flash exposure so it doesn't look too dark or too bright relative to the the natural light. For the photo at left, the sky was properly exposed, but the flash exposure was not enough. Photos by Julian Calder.

flash to underexpose the subject by one step to preserve the back lighting effect. You could do the same thing by moving the flash farther from the subject and use settings of *f*-5.6 at 1/60 second.

Flash as Main Light—On a dull, overcast day, use the flash as the main light with the weak daylight as fill. Meter the daylight. Select a flash-sync shutter speed and the recommended aperture.

Then adjust the aperture for one step less exposure due to daylight with color film or two steps less exposure with b&w. For the flash to be the main source, it must give good exposure at the aperture set on the lens. Use the GN formula to find flash-to-subject distance.

Angle the flash so it is above and to one side of the subject. You will need a flash-sync cord to do this. This way, the flash simulates the angle of light from direct sun.

Indoors—You can use flash to control the high lighting contrast sometimes created by a small or medium source indoors. The principle is the same—to record more detail in the shadow areas without burning out the highlights.

Meter the continuous light in the room and set a flash-sync speed and the recommended aperture. Divide the flash guide number by an *f*-number one step smaller than that set on the lens. This will give a flash-to-subject distance that retains the lighting effect of the continuous light—the flash acts as a fill light. Then close the lens aperture a half step to prevent overexposure of areas lit by both lights.

IMPROVING SHADOWS

The light illuminating shadows on a bright sunny day comes from reflections. This can be green light from green grass, or more typically, blue light from the sky. This kind of unpredictable color in the shadows is not always desirable. You can use flash to solve this problem. If your subject is completely in shadow, use flash as the main source, as described earlier.

When using flash as fill light to make shadows brighter, calculate flash exposure to give one step less exposure with color film and two steps less exposure with b&w film. Be sure to use a flash-sync shutter speed. Close the lens aperture about a half step for good exposures in areas lit by both flash and continuous light.

CREATING SPECIAL EFFECTS

When you use flash during the day, you may be able to reduce the continuous-light

▲ Usually, a subject with depth is not suitable for fill flash because the flash beam doesn't cover the scene uniformly. Unlit areas look unnatural when compared to the rest of the scene. Photo by David Morey.

◀ Here, Julian Calder allowed the warmth of the tungsten bulbs to dominate the effect. He used two flash heads to fill some dark areas with light, one bounced off the ceiling and the other directed toward the end of the room. To preserve the warmth of the scene, he used orange acetate filters over the flash heads and waited until late afternoon when the daylight intensity had decreased.

▶ To fill in some of the shadows, Malkolm Warrington used a flash bounced from the ceiling to act as a large-source light. This preserved the soft-lighting effect from the window.

exposure enough to make it much darker than the flash exposure. This means the flash acts as the main light. Meter the scene's continuous light and adjust the camera exposure controls to underexpose the daylight by at least three steps. Be sure to use a flash-sync speed. Use the GN formula and the aperture on the lens to calculate flash-to-subject distance. This gives exposure for the main subject.

Exposing the film this way makes the areas not lit by flash appear dark. Only those parts that are flash lit will be correctly exposed. This gives a "flash at night" effect. To make this technique possible on bright days, use slow film.

Flash mixed with daylight can also be used to produce a double image of a moving subject. See the photo at right.

▼ For this photo, Chris Alan Wilton used exposure settings to slightly underexpose the background. For special effect, he positioned the flash for good exposure on the foreground.

▲ The blur indicates that the boy moved backward. The effect was created with an on-camera flash and a slow shutter speed. The blurred image is due to the boy moving during exposure. Photo by Michael Buselle.

▶ Julian Calder simulated the effect of daylight by using a diffused flash from overhead. This froze motion of the bird.

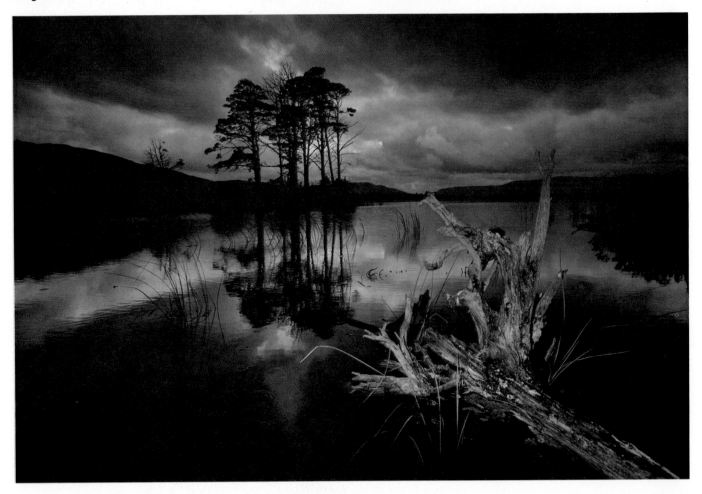

Mixing Daylight and Artificial Light

At times, you will encounter mixed lighting conditions. These include daylight mixed with tungsten light, daylight and fluorescent light, and street lights at dusk. Each presents a different lighting problem and solution.

COLOR CASTS

Color film is balanced to give best color reproduction with light of one color—midday daylight or 3200K or 3400K tungsten light. Consequently, when you take a color picture of a scene lit by both daylight and artificial light other than flash, the film will have a color cast due to the source with the incorrect color.

If you use daylight film to photograph a subject lit by both tungsten and daylight, the film has an orange cast from the relatively warmer tungsten light. If you use tungsten film in daylight, areas lit by daylight reproduce relatively bluer.

You can take advantage of these effects. For example, the warm glow of a table lamp in the background of a daylit indoor portrait can add a pleasing effect. At dusk, tungsten film can make the colors of tungsten-lit window displays and signs look even more brilliant relative to the surrounding exaggerated blue gloom.

It is important to decide which part of the subject you want to record with correct colors. Then use the color film that is balanced for the light in that area. Usually, but not always, you'll get best results when the main subject or the largest part of the scene is reproduced properly. Let the color cast provide an accent of unusual color.

At first, you may find it difficult to actually see the color difference between two light sources. In this case, you have to be *aware* of the sources lighting the scene and *know* how they affect color film. For exam-ple, when you read a book under tungsten light, you see the pages as white even though they are colored yellow by the light. Daylight color film reproduces the pages as yellow. Experience is the best teacher in this instance. After taking a few pictures under mixed lighting conditions, you will quickly learn to predict results.

DIFFERENT FILMS

Different brands and types of color film do not produce the same colors when re-producing the same scene. Each film has a unique sensitivity to different colors of light. The dyes that reproduce the colors are also different with each brand of film.

Therefore, the effectiveness of a mixed-light photo may depend on which color film you use. This is a matter of personal taste. You can learn a film's characteristics only by using it with a variety of subjects and different lighting conditions.

EXPOSURE

Exposure is another factor that controls the effect of color casts in mixed lighting. Consider a scene at dusk that includes street lights in the picture area. If you expose for the darker areas of the scene, the lights will be greatly overexposed relative to the rest of the scene. Any color cast in the lights will burn-out due to overexposure.

Similarly, a photo made indoors by tungsten lighting on tungsten film shows window light less blue if exposure is based on the dark parts of the interior scene.

SKIN TONES

Another thing to consider when expecting a color cast due to mixed lighting is the effect it will have on skin tones, particularly if they are a dominant part of the picture. Generally, a warm orange or yellowish cast on skin tones is acceptable—sometimes even desirable. A cold blue cast is usually unattractive and is best avoided.

▲ Adam Woolfitt used daylight film for this Amsterdam scene. This makes the lights seem warm. Tungsten film would have reproduced the lights more neutral.

◀ In this picture, the highlights due to the tungsten light are as important as the boats. Adam Woolfitt used daylight film to exaggerate the warmth of the tungsten lights.

▶ The mild blue sky of early evening has been intensified by the blue cast produced by tungsten film. The leaves lit by the street lamp are rendered in almost their actual color. Photo by Michael Busselle.

FLUORESCENT AND DAYLIGHT

Another common case of mixed illumination is fluorescent light mixed with daylight. Fluorescent light may look the same color as daylight, but actually it isn't. These tubes create *some* light that is nearly the same color as daylight. However, they also create "spikes" of green and blue light. The relative amounts of these spikes depend on the type of fluorescent bulb. Several types are available.

The effect on daylight film is typically a bluish-green cast. This is not very appealing—especially with skin tones. In addition, different types of bulbs are often used together, such as in ceiling fixtures in a large office. This makes the photographic effect unpredictable.

CORRECTING COLOR CASTS

When shooting scenes with mixed lighting, usually you should balance film with the main light source. This is relatively easy if daylight and tungsten light are in the same scene, but it is less easy if one light is not a standard source, or if you want to eliminate both color casts.

Fluorescent tubes and daylight are a typical example. If you use daylight film, the film looks good in daylit areas but bluish-green in the areas lit by fluorescent tubes. Correct this color cast by using magenta and yellow filtration over the lens. Color-compensating (CC) filters can be used this way, but to get the right combination of the two colors, you usually have to do a photographic test with different filtrations. An easier way is to buy a glass filter designed for average fluorescent bulbs. These are usually called *FL-D*, for *fluorescent-to-daylight.*

When you correct the color this way, the daylit areas have a warm color cast due to the filter. If this bothers you, minimize the daylit areas because correcting this color cast is not always practical.

The photo above shows the bluish-green cast typical of fluorescent lighting reproduced on daylight film. Window light is reproduced correctly. When an FL-D filter is used to correct the color cast (below), window light reproduces with a pink cast.

▲ Because the most important elements of this scene were lit by daylight, Michael Busselle used daylight film. The tungsten lights in the background appear yellow, but natural.

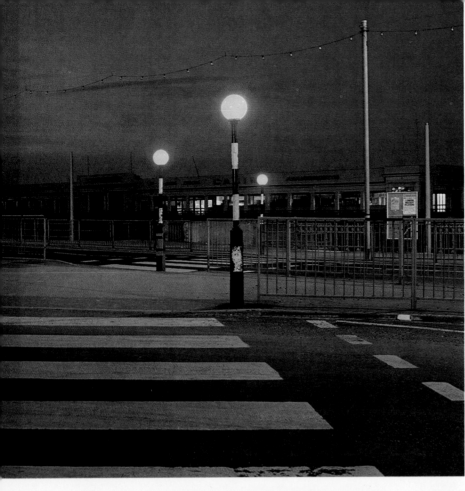

If a window is admitting daylight, you could cover the window with tinted acetate sheets selected to counteract the color cast. These acetate sheets are also available in blue and orange colors to balance window light with daylight or tungsten light. However, this material is expensive. It is available from motion-picture-supply outlets. If the window area is large, the best solution may be to turn off the artificial light and supplement the daylight with flash.

◄ An intense yellow cast can be acceptable, or even desirable. John Sims used daylight film to exaggerate the color of the artificial lights.

▼ When you make abstract photos, "correct" color rendition is usually unnecessary. Daylight film was used in this photo by John Sims.

Mixed-Lighting Summary

Of all aspects of photography, lighting is possibly the most complicated. It can affect composition, exposure, and choice of film. If the lighting is inappropriate for a particular situation, you will almost certainly end up with an unsatisfactory picture. If the lighting suits the subject and mood you are trying to convey, you should get a good photograph.

There are ways to control lighting to make it suit the scene. Intelligent use of additional lighting—whether it be flash, tungsten or fluorescent—can improve, supplement or simulate available light. Used incorrectly, these additional light sources can ruin the original mood and create an unnatural looking picture.

BREAKING THE RULES

As with most guidelines, you should understand and use these ideas, but not see them as inviolable laws. There may be occasions when it will be to your advantage to not follow them. For example, you may

like the effect of daylight recorded on tungsten film and think that the predominantly blue cast works well with the subject.

Or, when using flash, you may want your subject to stand out as though entirely separate from its background. It is then valid to ignore all the advice about producing a brightness balance between subject and surroundings.

The most important thing is to have a *clear understanding* of how different types of light affect film. With this knowledge you are better able to visualize the effect in the image. You will know when you can get a good picture and when you would be wasting your time.

▼ When using tungsten film for an interior scene, wait until dark if you want to avoid the effects of daylight. Photographic tungsten lights were used with tungsten-balanced film.

TUNGSTEN-BALANCED FILM

◀ This is a typical example of mixed lighting—an interior lit by both tungsten light and daylight. Photographer Angelo Hornak lowered lighting contrast due to the medium window source by placing a tungsten photographic lamp to the right of the camera. He used tungsten film in the camera, so daylight coming through the window has a blue cast.

▼ Here, household lamps were the only light source. The resulting image has an overall warm cast. This happens because tungsten film is balanced for photographic tungsten light, *not* for the much warmer light of household bulbs.

DAYLIGHT-BALANCED FILM

▶ Daylight film is the obvious choice when the subject is lit by daylight only. However, as this picture shows, daylight coming through one window is rarely sufficient to light an interior completely. Even though bright areas are exposed correctly, shadows are still very dark. This is due to high lighting contrast.

▼ The lighting here was a mixture of daylight and fill flash. The flash was fired four times manually during a long exposure time. The effect is very natural and shadow detail is good. However, because the combined effect of the flashes and daylight cannot be seen until the film is processed, success with this technique is largely a matter of experience, testing, and guesswork.

DAYLIGHT-BALANCED FILM
◀ To eliminate guesswork when using fill lighting, use a *continuous* source, such as a tungsten light. You can then see the effect before making the picture. Here, Angelo Hornak used a tungsten lamp to fill shadows. The film reproduces the tungsten-lit areas with a warm cast, but this is not objectionable.

▼ One solution to the problem of mixed lighting is to change the color temperature of one of the sources. Here Angelo Hornak used a tungsten light to fill shadows. To balance the light with daylight coming through the window, he placed a blue light-balancing filter over the tungsten lamp.

Night Photography

Using your camera at night can be more exciting and challenging than photographing by daylight—even when you leave your flash at home. The nighttime photographer uses the lights of man and nature to illuminate darkness. These are sometimes more diverse and colorful than daylight.

During the day we see clearly, so we expect film to reproduce what we see. At night it is different. We not only see less, but sometimes less brilliant color, detail and clarity. Film, however, can "add up" light and reproduce colors we cannot see or appreciate at night. For example, one bright light in the darkness can prevent us from seeing into adjacent darker areas. Film does not have this limitation.

LIGHT AS THE SUBJECT

Consider the variety of light sources you've seen at night: street lights, car headlights, lighted windows and signs, the moon and stars, reflections on water, fires, fireworks, Christmas lights, and more.

These sources can be *the subject* of a nighttime photo. They can become color, shape or movement, rather than just the light source for a scene. Used this way, the light can be photographed with relatively short exposure times for a static effect. Or, you can use long exposure to make streaks of light, such as when a car drives by, or when you move the camera.

LIGHTED SUBJECTS

Scenes illuminated by night lights are another aspect of night photography. The mood of the situation is preserved in the photo by the lit area surrounded by dense black. This happens because relatively small sources light large areas, giving high lighting contrast. The amount of light diminishes rapidly at greater distances from the source.

Typical scenes are those lit by a full moon in a clear sky, moving spotlights shining on a building, city lights reflecting around the urban landscape, or people next to window displays. Generally, such scenes require longer exposures than if the subject were the light source.

LIGHT AND SUBJECT

For some pictures you will want to show both the light source and the illuminated subject. Usually, the closer your subject is to the source, the better the result. This increases the relative size of the source and reduces lighting contrast. If the subject is far from the light source and you meter

▲ Midday sunlight illuminates the fountain well for an ordinary snapshot. But at night, artificial lights and slower shutter speed create a more mysterious mood. Photos by Dan Budnik.

▼ Robert Glover metered the candle-lit face by moving in close. This excluded the effect of the predominantly dark background. Notice the color of the candle-lit skin tones on film.

for the subject, the source will be grossly overexposed and will burn out in the resulting picture.

For example, suppose you photograph a scene lit by the moon, and you expose film long enough to make detail distinct. If the moon is also imaged, it becomes a white streak due to overexposure and the rotation of the earth.

METERING

One problem with making nighttime photos is metering. There are a few ways that the nonaverage nature of these subjects complicates metering.

Sensitivity Range—The meter in an SLR may not be sensitive enough to give reliable exposure recommendations for some scenes. Some cameras signal you if the light is below the metering range. In this case, you should base exposure on tests, a good guess, or by bracketing. Some hand-held accessory meters are more sensitive to low-light scenes than camera meters.

▶ This image was exposed for 30 seconds at *f*-22 on ASA 64 daylight film. A longer exposure would have shown more detail on the tower but would have made the whirling street lights too bright. The lights on moving cars created the streaks in the bottom of the scene.

Metering Cell—The metering cells of most SLRs are CdS, silicon, or gallium. CdS cells are least sensitive. In addition, CdS cells have a "memory." If you meter a bright scene, then meter a low-light scene, the cell's memory makes the resulting low-light reading unreliable. Avoid this problem by letting the cell recover for about 30 seconds after a bright-light reading. Silicon and gallium cells do not have a memory and respond quickly to low-light scenes.

Exposure Tables and Bracketing—Because of the variety of night scenes and the number of possible effects you can get, it is difficult to give general exposure guidelines. The accompanying table gives you starting points for your own tests when using ASA 400 film. In addition, the instruction sheet that comes with most films gives exposure recommendations for some low-light scenes.

When using such information, or when your meter recommends an exposure, you can guarantee getting a good picture by making several pictures with different exposures. Use the meter, an exposure guide, or your best guess as a starting point and make an exposure. Then make exposures one, two and three steps over this setting.

If you wish, you can also make an exposure at one step of underexposure, but this is rarely necessary. Depending on your experience with the scene and the meter, you may want to bracket more or less. If the situation is a once-in-a-lifetime opportunity, bracket extensively. If it is a scene you can photograph again, bracket less. You'll become better able to predict the results of nighttime shooting if you write down exposures when you bracket. Later, you can see which exposure gave best results.

SUBJECT	TYPE OF LIGHTING	EFFECT	ASA 400 EXPOSURE
Street scene	Sodium or mercury vapor lighting	Dark / Bright	1/60, ƒ2.8 / 1/125, ƒ2.8
Shop window	Small store / Spotlit items / Very bright	Normal / Normal / Normal	1/20, ƒ2.8 / 1/30, ƒ4 / 1/30, ƒ5.6
Street lights	Mixed	Lights only	1/30, ƒ4
Bonfire	Flames	Fire / Fire & People	1/30, ƒ4 / 1/15, ƒ2.8
Fireworks	Mixed / Sparklers	Light / People	1 sec., ƒ4 / 1/30, ƒ2.8
Car lights (50 mph)	Light source	Streaks	1/30, ƒ2 / 10 sec., ƒ8
Neon signs		Light source	1/60, ƒ5.6
Floodlit	Various	Normal	1/60, ƒ5.6
Floodlit buildings	Various	Normal	1/8, ƒ2.8
Moon	Clear night	Detail	1/250, ƒ16

▶ Photographing this light source at night was easy because the lights are bright. Alfred Gregory used an exposure of 1/60 second at ƒ4 with tungsten-balanced ASA 200 film.

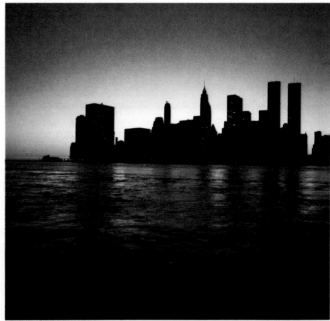

These photographs of the Manhattan skyline were taken within 30 minutes at dusk. Clive Sawyer used an aperture of ƒ4 for all three, adjusting only shutter speed to deal with the changing light.

The photo above was exposed for 1/30 second, too fast to show anything but a silhouette. The photo above right was made at 1/8 second, long enough for some of the lighted windows to expose film. This also brightened the sky. The photo at right was exposed for the city lights and their bright reflections in the water. The shutter was open for 15 seconds.

RECIPROCITY FAILURE

A characteristic of general-purpose b&w and color film is that when the correctly calculated or measured exposure time is longer than about 1/2 second, the film looks underexposed. For example, an exposure of 1/4 second at *f*-2.8 *should* give the same photographic effect as 1 second at *f*-5.6. However, due to long-exposure reciprocity failure, the second frame appears darker than the first. In addition, color film undergoes a color shift. With b&w film, contrast usually increases.

You can solve these problems by using a faster film or by giving the film more exposure than the meter recommends. Typically, this is one or two steps. When shooting color transparency film, filtration is also recommended, although for some scenes it isn't necessary. B&w film requires extra exposure and change in development time to adjust contrast.

Film manufacturers give exposure and filtration recommendations for exposure times that produce reciprocity failure. These too are guides. Extensive bracketing and careful record keeping are recommended. The long exposures in the exposure table in this section are adjusted for the effect of long-exposure reciprocity failure for a typical ASA 400 color film.

EQUIPMENT

Consider using this equipment when doing nighttime photography:

Tripod—This is handy when you photograph at night. With it you can hold the camera still for long exposures. Generally, you should use a tripod or other firm

camera support for exposures longer than 1/60 second.

Locking Cable Release—When the camera shutter-speed setting is set to **B**, the shutter stays open as long as the button is depressed. Releasing the button ends exposure. Using a locking cable release frees you from having to hold the shutter button for long exposures. After you depress the plunger of the cable release, lock the plunger. The shutter stays open until you unlock the plunger. This lets you leave the camera so you can fire a flash, if necessary.

Flashlight—When it is dark, seeing camera controls and focusing can be diffi-

▲ Eric Hayman determined exposure for this photo by metering the sky with his camera meter. This reproduced the sky as a middle tone and silhouetted the structure.

▶ Robert Estall made this photo of Piccadilly Circus with a shutter speed of 10 seconds. This was long enough for cars to pass through the scene, leaving trails of light.

◀ To achieve the correct lighting balance between the artificial lights and sky light, Dan Budnik bracketed exposures. This is the preferred result.

▼ Mixed artificial lights can give unpredictable results. Laurie Lewis used tungsten-balanced film to record this scene lit by floodlights and lasers.

cult. Bring along a flashlight to make focusing and camera operation easier.

Watch—When making long exposures with the **B** setting of the shutter-speed dial, an accurate way of measuring exposure time is useful. You can count, "One thousand one, one thousand two, one thousand three, etc.", but five minutes of this can be tedious. Instead, you'll find it easier to use a watch to time the exposure.

Auto-Focusing Cameras—Some non-SLR 35mm cameras can focus on a subject automatically—even at night. If you have one of these, try using it outside for night photography.

SELECTION CHART FOR COMMONLY USED FILTERS

FILM TYPE	DESIRED RESULT	LIGHT ON SCENE	VISUAL COLOR OF FILTER	HOYA	TIFFEN	VIVITAR	BDB FILTRAN	FILTER FACTOR (Approx.)
Any	Reduce UV exposure of film	Day	Clear	UV	Haze 1	UV-Haze	UV-Haze	1X
	Reduce amount of light 2 steps without affecting colors	Any	Gray	NDX4	ND 0.6	ND-6	ND4X	4X
	Reduce amount of light 3 steps without affecting colors	Any	Gray	NDX8	ND 0.9			8X
	Soften facial lines in portraits, soften lines in any image	Any	Clear	Diffuser	Diffusion Filter #1	Soft Focus	Soft Focus	1X
	Increase softening effect	Any	Clear	Soft Spot	Diffusion Filter #3			1X
B&W	Darken blue sky and sea, lighten clouds for contrast	Day	Light Yellow	K2	6	K2	Yellow	1.5X
	Stronger sky/cloud contrast, lighten yellow and red	Day	Dark Yellow		9	G-15		2X
	Outdoor portraits, natural reproduction of foliage	Day	Green	X1	11	X1	Green	2X-4X
	Improve contrast of distant landscapes, penetrate haze	Day	Orange	G	16	O2	Orange	3X
	Exaggerate sky/cloud contrast, dramatic landscapes	Day	Red	25A	25A	25(A)	Red	8X
Day-Light COLOR	Reduce blue effect of open shade, overcast days, distant mountain scenes, snow	Day	Very Faint Pink	1B	SKY 1A	1A	Skylight 1A	1X
	Warmer color in cloudy or rainy weather or in shade More effect than Skylight filter	Day	Pale Orange	81C	81C	81C	R1-1/2	1.5X
	Reduce red color when shooting daylight film in early morning or late afternoon	Day	Light Blue	82C	82C		B 1-1/2	1.5X
	Use with daylight film for shooting with clear flashbulbs at night or indoors	Clear Flashbulb	Blue	80C	80C	80C	B6	2X
	Normal color when exposing daylight film under 3400K tungsten lighting	Tungsten	Blue	80B	80B	80B	80B	3X
	Normal color when exposing daylight film under 3200K tungsten lighting	Tungsten	Dark Blue	80A	80A	80A	80A	4X
	Reduce blue-green effect of exposing daylight film under fluorescent lighting	Fluorescent	Purple	FL-D	FL-D	CFD	DAY FL	1X
Tungsten COLOR	More natural color with tungsten film exposed by daylight in morning or late afternoon	Day	Amber		85C		R3	2X
	Natural color with tungsten Type A film exposed by midday sunlight	Day	Amber	85	85	85	85	2X
	Natural color with tungsten Type B film exposed by midday sunlight	Day	Amber	85B	85B	85B	85B	2X
	Reduce red effect of shooting tungsten films under ordinary household incandescent lights	Incandescent	Light Blue	82C	82C		B 1-1/2	1.5X
	Reduce blue-green color effect of shooting tungsten film with fluorescent lighting	Fluorescent	Orange		FL-B	CFB	ART FL	1X

NOTE: Filters made by different manufacturers are not represented to be exact equivalents even though labeled the same or designated for the same purpose. These filters should be approximately equivalent and satisfactory for the indicated uses. Filter factor may vary with brand.

Index